# As They Were Too

A Collection of Celebrated People's Childhood Photos

## by Tuli Kupferberg

## & Sylvia Topp

Here are men and women "as they were"
What happens to them? They stir
Or are stirred: to love's victory (or defeat)
God (or fate): Make our children sweet!

quick fox

NEW YORK  LONDON  TOKYO

Book Design by Barbara Hoffman

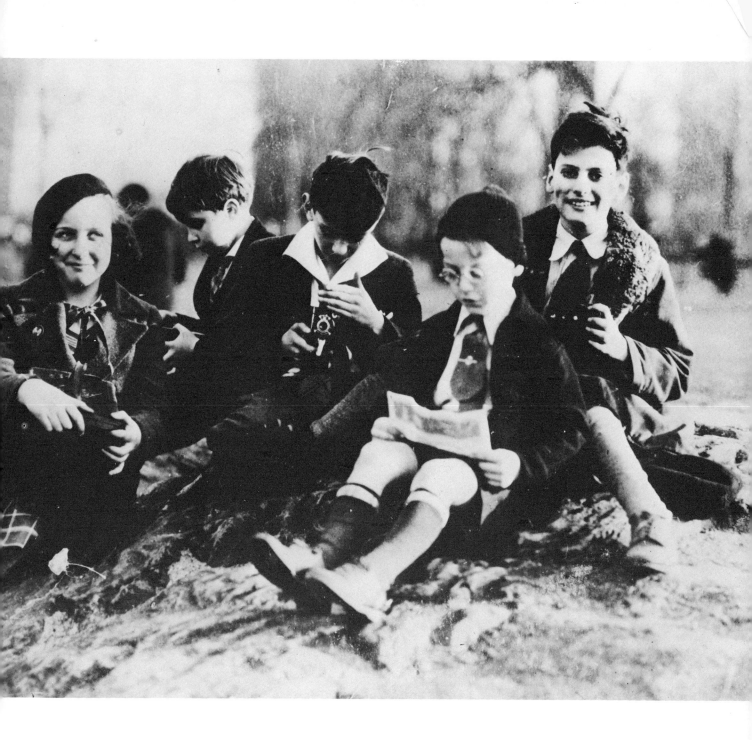

# Richard Avedon

On right, age 12. With YMHA Camera Club in Central Park, New York City.

Born May 15, 1923, in New York City.

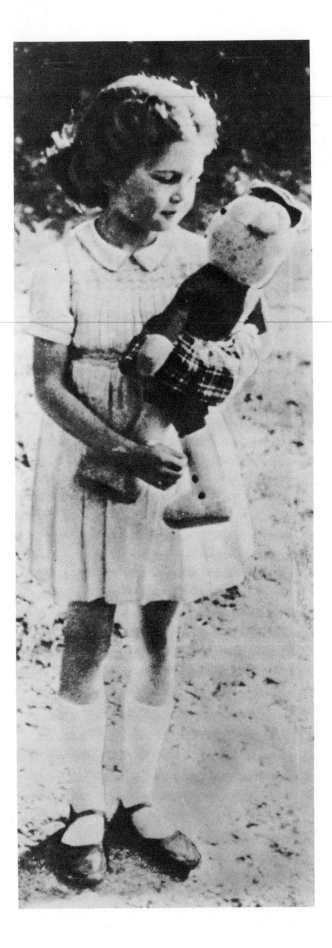

# Brigitte Bardot

Born September 28, 1934, in Paris, France.

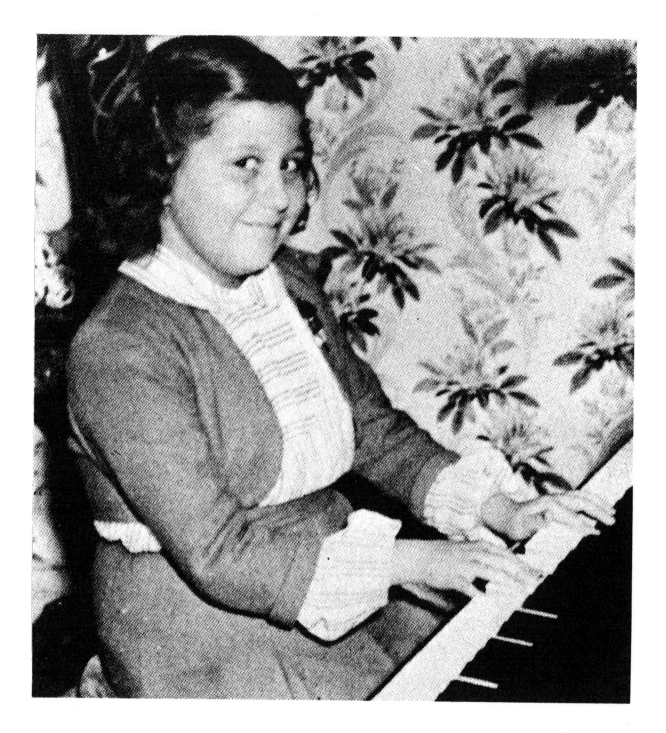

# Rona Barrett
Age 9.

Born October 1937, in New York City.

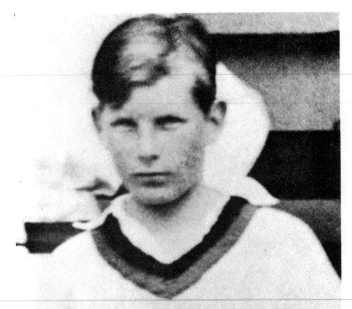

# Samuel Beckett
About 14. At Portora Royal School,
Enniskillen, Fermanagh, Northern Ireland.

Born April 13, 1906, in Foxrock, Dublin, Ireland.

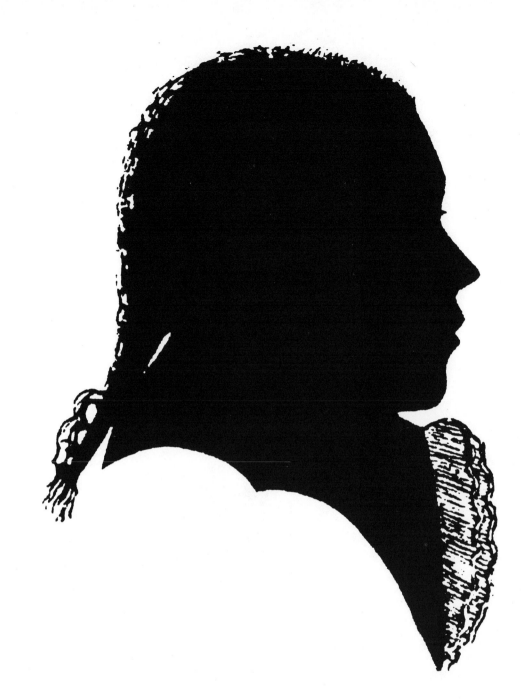

# Ludwig van Beethoven
Age 16.

Born December 16 or 17, 1770, in Bonn, Germany.

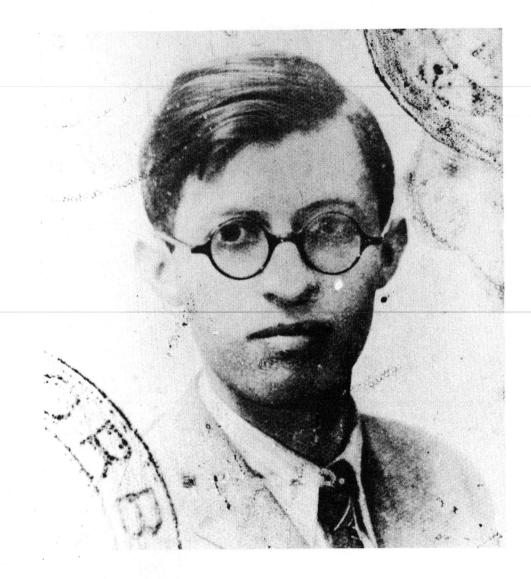

# Menahem Begin

When a university student in Poland.

Born August 16, 1913, in Brest-Litovsk, Russian Poland.

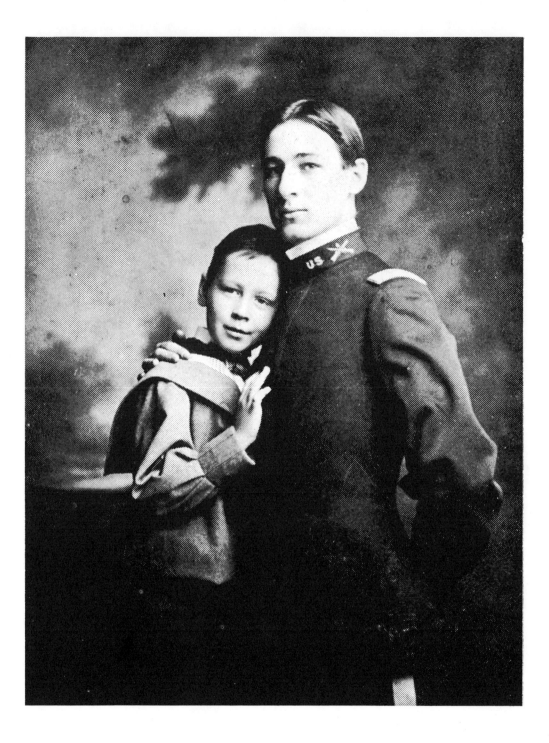

# Robert Benchley

With his brother Edmund who was killed a few
years later in Cuba during the Spanish-American War.

Born September 15, 1889, in Worcester, Massachusetts.

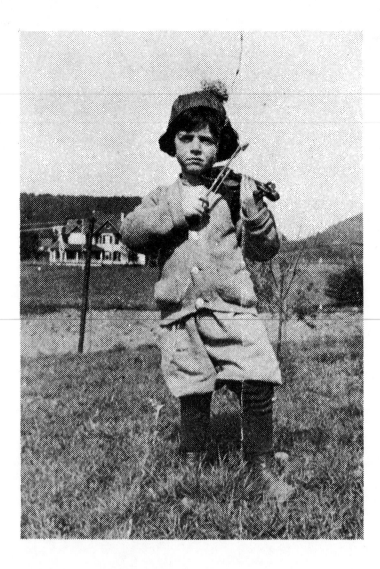

# Milton Berle

Age 4.

Born July 12, 1908, in New York City.

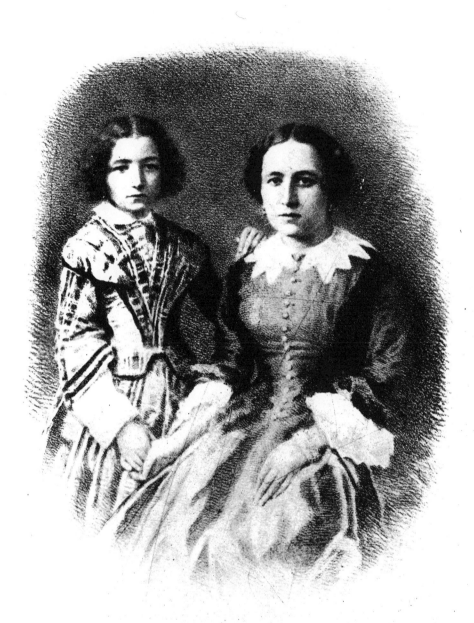

# Sarah Bernhardt

With her mother Judith.

Born October 22 or 23, 1844, in Paris, France.

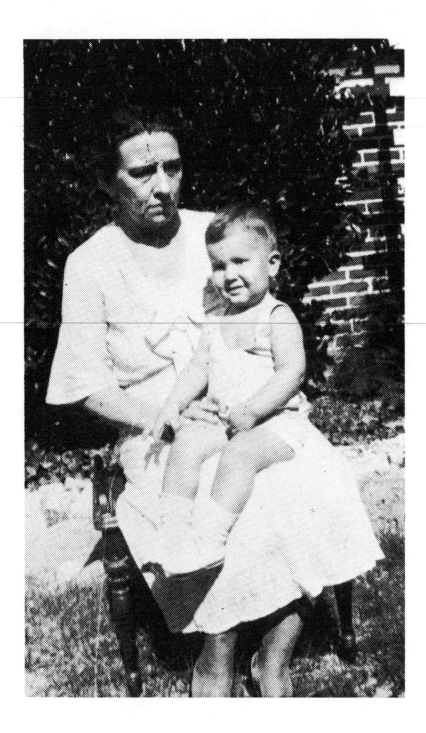

# Pat Boone

With his Grandma Pritchard.

Born June 1, 1934, in Jacksonville, Florida.

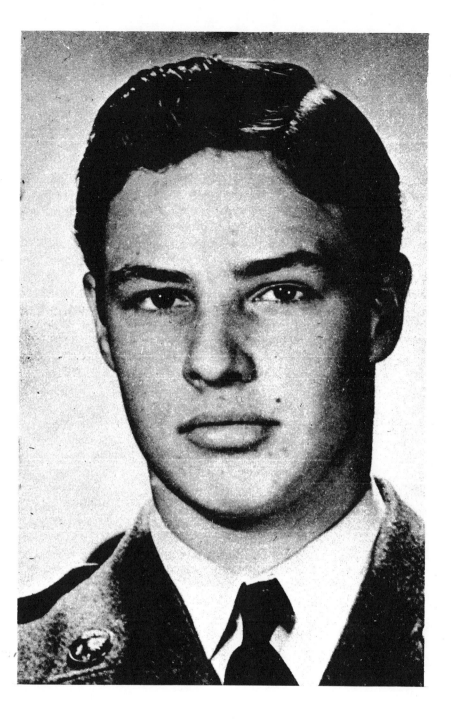

# Marlon Brando
About 18. Before he was expelled from
Shattuck Military Academy, Faribault, Minnesota.

Born April 3, 1924, in Omaha, Nebraska.

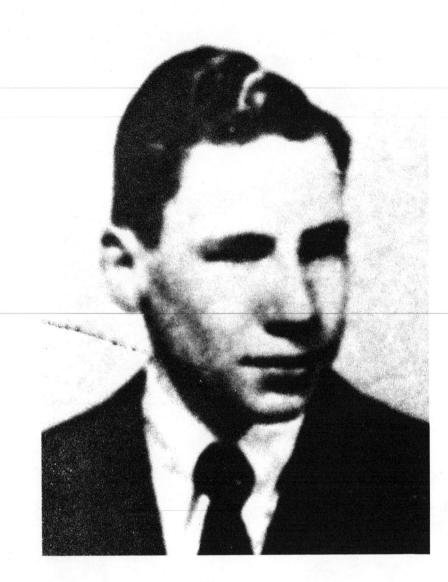

# Mel Brooks
Class of 1944, Eastern District High School, Brooklyn, New York.

Born June 28, 1926, in Williamsburg, Brooklyn, New York.

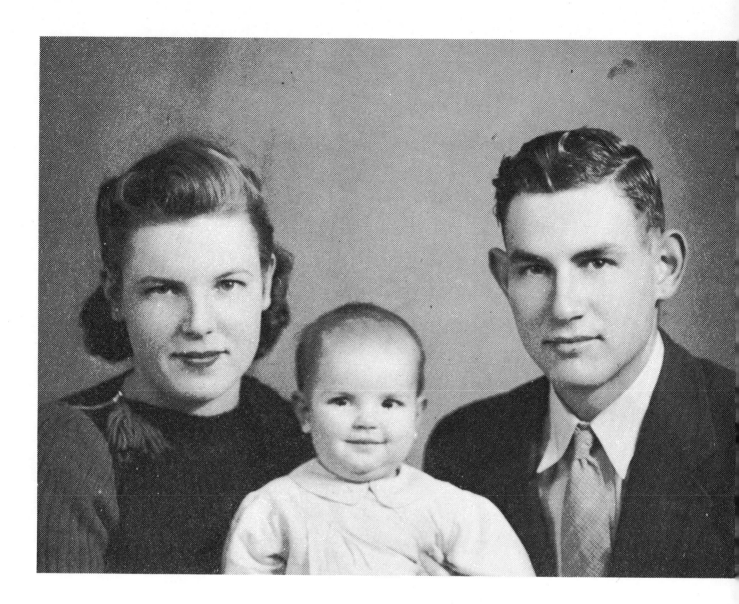

# Anita Bryant
With her mother Lenora and father Warren.

Born March 25, 1940, in Barnsdall, Oklahoma.

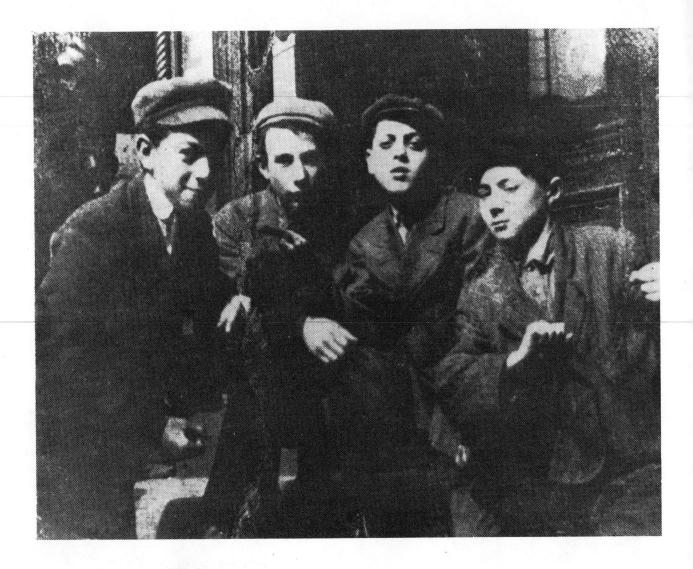

## George Burns

On left, about 8. With the Peewee Quartet.
Born January 20, 1896, in New York City.

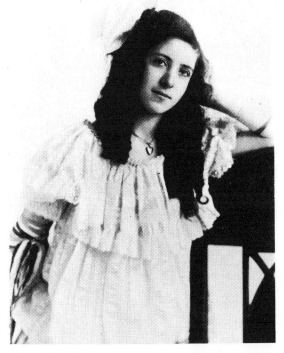

## Gracie Allen

Age 16.
Born July 26, 1906, in San Francisco, California.

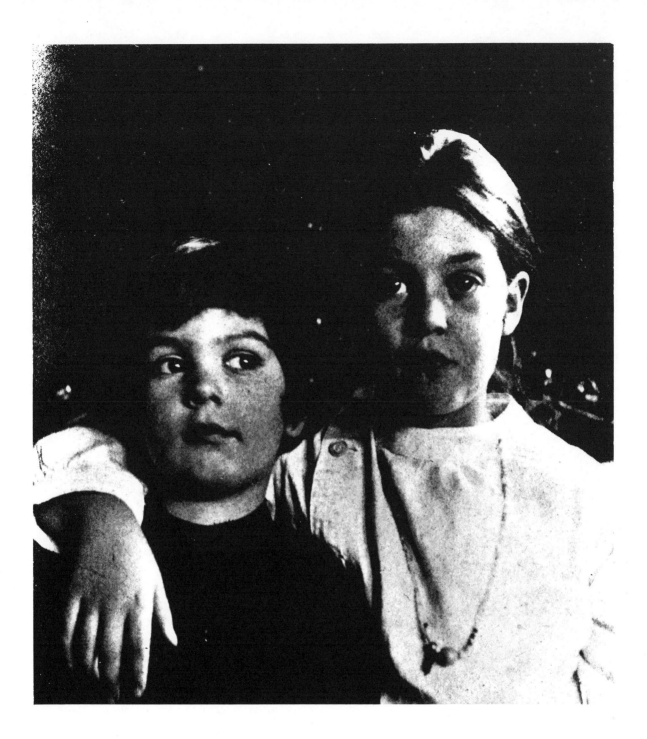

# Alexander Calder
About 7. With his sister Peggy.

Born July 22, 1898, in Lawnton, Pennsylvania.

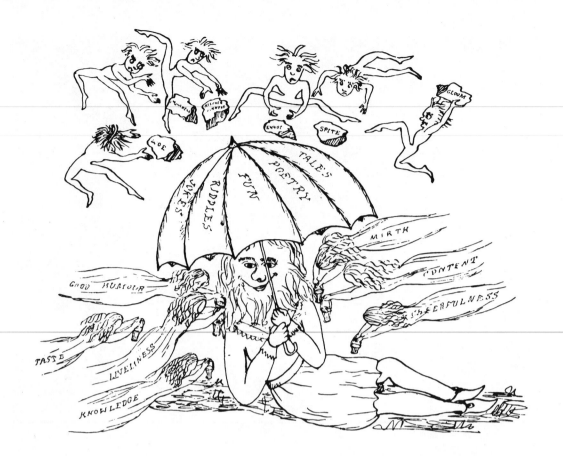

# Lewis Carroll

Age 8.

Born January 27, 1832,
in Daresbury (near Warrington),
Cheshire, England.

Cover of *The Rectory Umbrella*,
a Dodgson family magazine,
drawn by Lewis at age 18.

MY FAIRY

I have a fairy by my side
　　Which says I must not sleep,
When once in pain I loudly cried
　　It said "You must not weep".

If, full of mirth, I smile and grin,
　　It says "You must not laugh";
When once I wished to drink some gin
　　It said "You must not quaff".

When once a meal I wished to taste
　　It said "You must not bite";
When to the wars I went in haste
　　It said "You must not fight".

"What may I do?" at length I cried,
　　Tired of the painful task.
The fairy quietly replied,
　　And said "You must not ask".

*Moral:* "You mustn't".

(about 13)

# Johnny Carson

About 18. High school yearbook photo,
Norfolk Senior High School, Norfolk, Nebraska.

Born October 23, 1925, in Corning, Iowa.

# Jimmy Carter
Age 2.
Born October 21, 1924,
in Plains, Georgia.

# Rosalynn
# Smith Carter
Age 10.
Born August 18, 1927,
in Plains, Georgia.

# Gloria
# Carter Spann
Age 3. With her brother Jimmy.
Born October 22, 1926,
in Plains, Georgia.

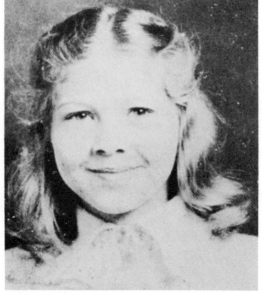

# Billy Carter
About 15.
Born March 29, 1937,
in Plains, Georgia.

# Ruth Carter
# Stapleton
About 10.
Born August 7, 1929,
in Plains, Georgia.

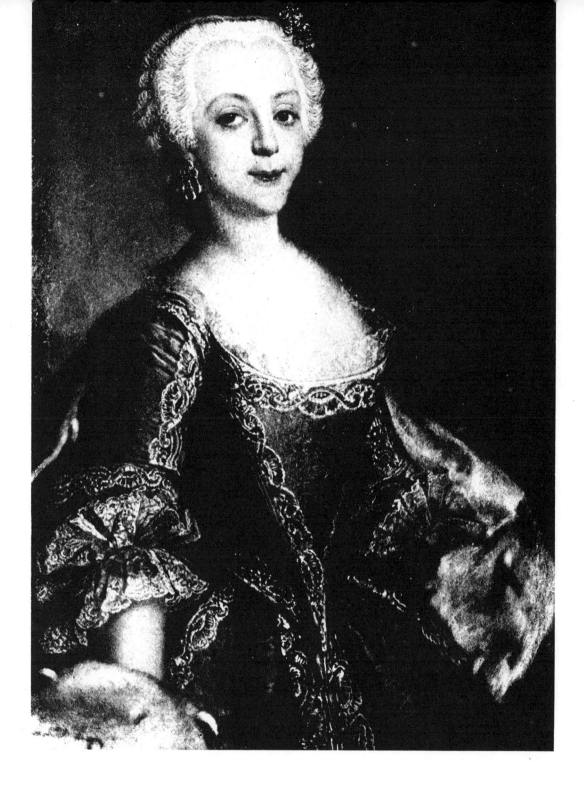

# Catherine the Great

About 15.

Born May 2, 1729, in Stettin, Pomerania.

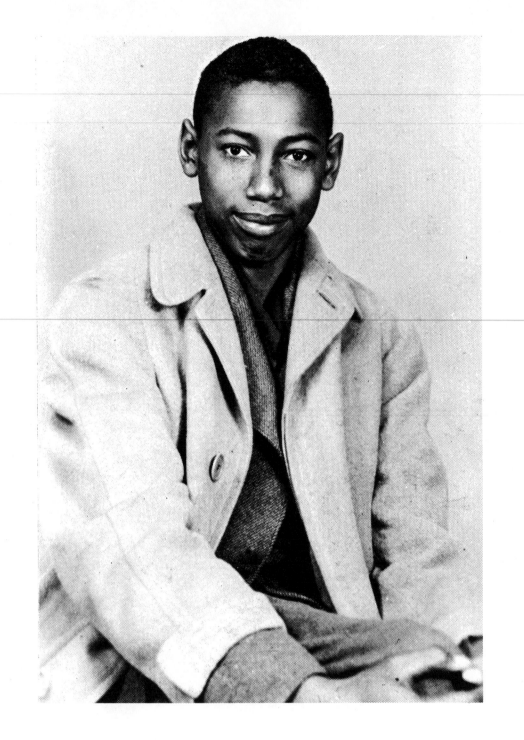

# Wilt Chamberlain
Age 12.

Born August 21, 1936, in Philadelphia, Pennsylvania.

# Cher
Age 9.

Born May 20, 1946, in El Centro, California.

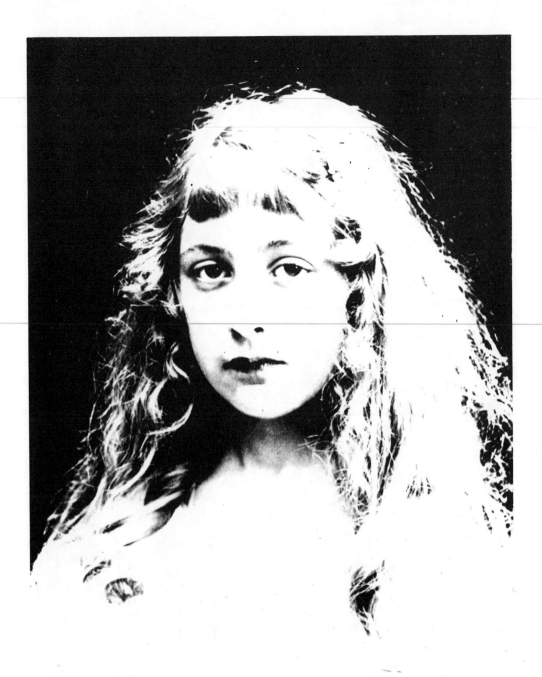

# Agatha Christie

Born September 15, 1890, at Ashfield in Torquay, Devon, England.

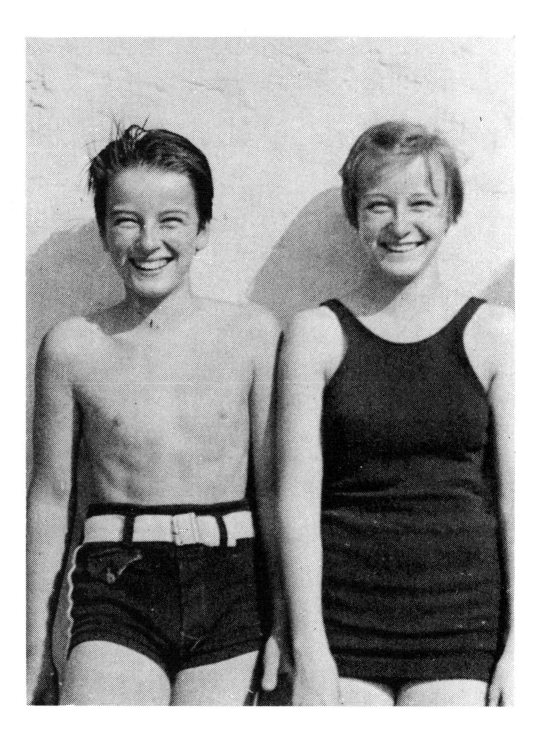

# Montgomery Clift
About 13. With his twin sister Ethel in Fort Lauderdale, Florida.

Born October 17, 1920, in Omaha, Nebraska.

# Leonard Cohen

An early performance.

Born September 21, 1934, in Montreal, Canada.

# Colette
About 15.
Born January 28, 1873, in Saint-Sauveur-en-Puisaye, Burgundy, France.

# Alice Cooper
Age 5.

Born February 4, 1948, in Detroit, Michigan.

# Salvador Dali

Born May 11, 1904, in Figueras, Gerona, Spain.

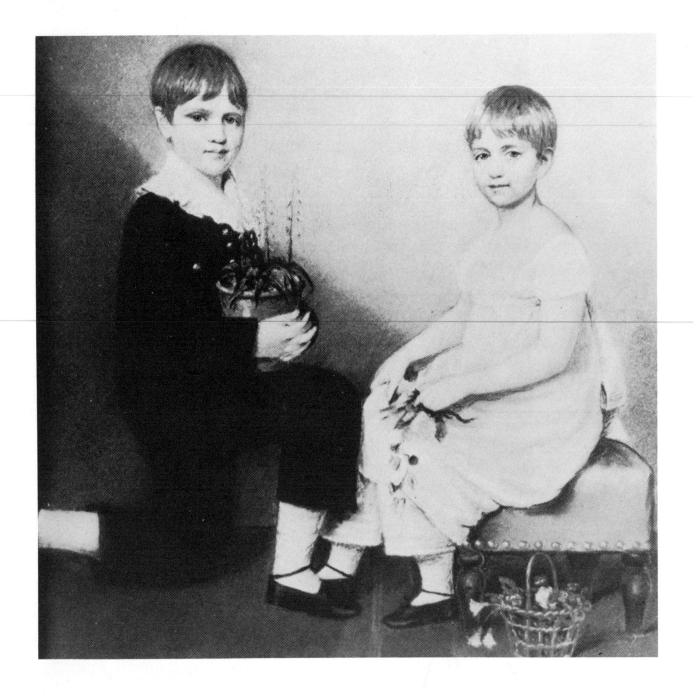

# Charles Darwin

Age 6. With his sister Catherine.

Born February 12, 1809, in Shrewsbury, Shropshire, England.

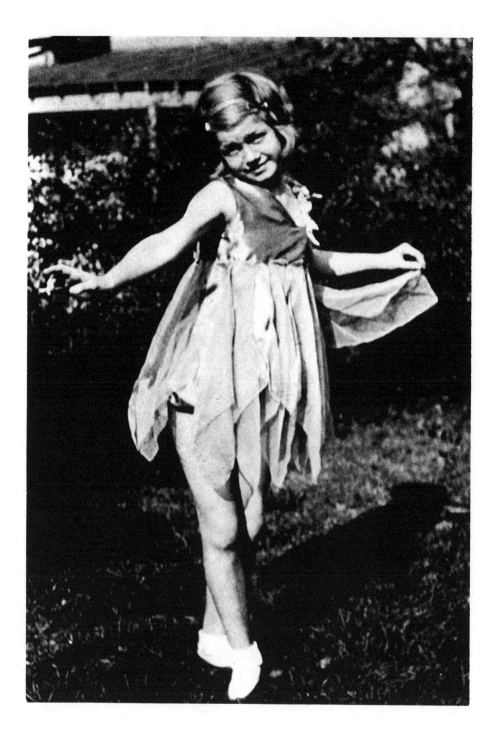

# Doris Day

Born April 3, 1924, in Cincinnati, Ohio.

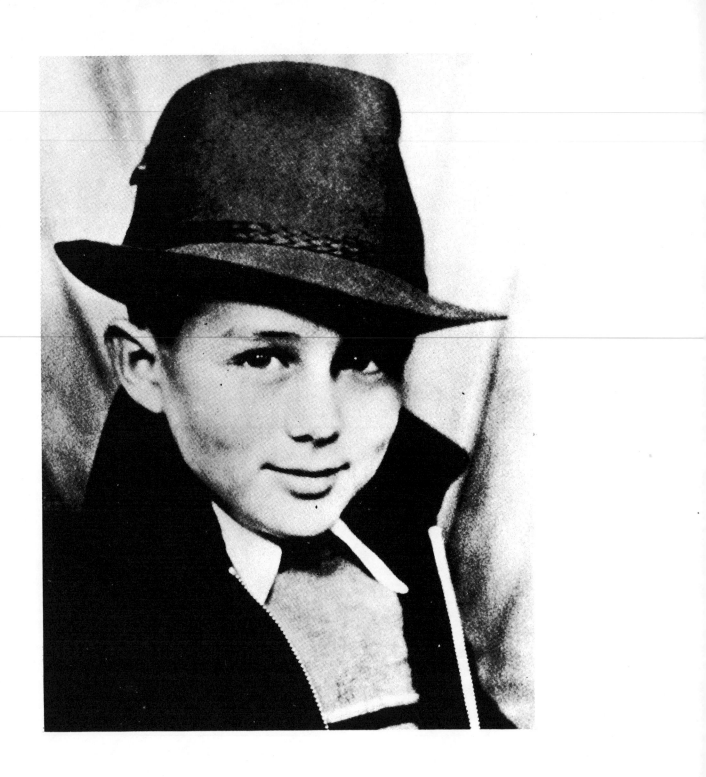

# James Dean
Age 9.

Born February 8, 1931, in Marion, Indiana.

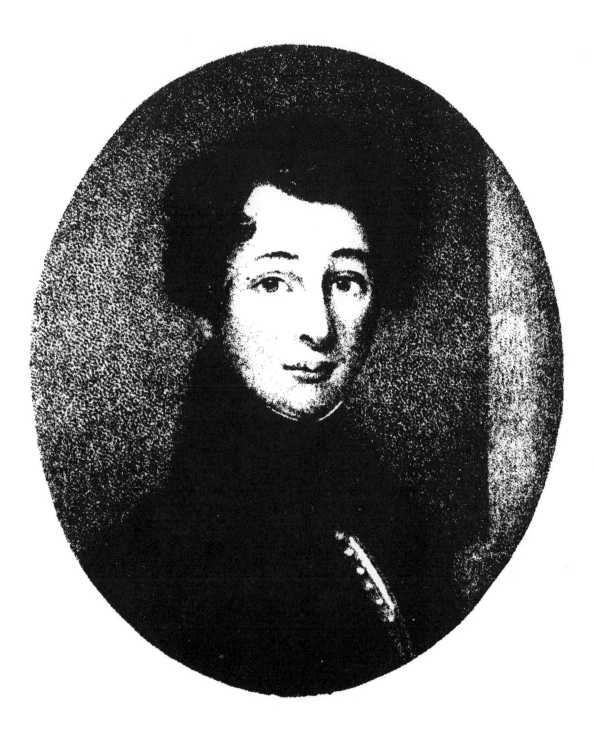

# Charles Dickens

Age 18. Miniature by his aunt Janet Barrow.

Born February 7, 1812, in Portsmouth, England.

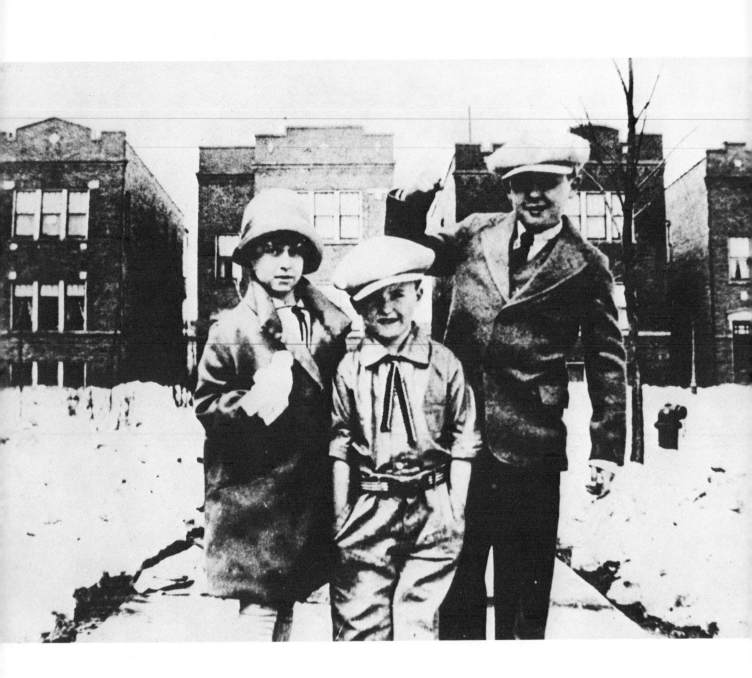

# Mike Douglas
Center. With his sister Helen and brother Bob.

Born August 11, 1925, in Chicago, Illinois.

# Arthur Conan Doyle
Age 5. Pencil drawing by his uncle Richard Doyle.

Born May 27, 1859, in Edinburgh, Scotland.

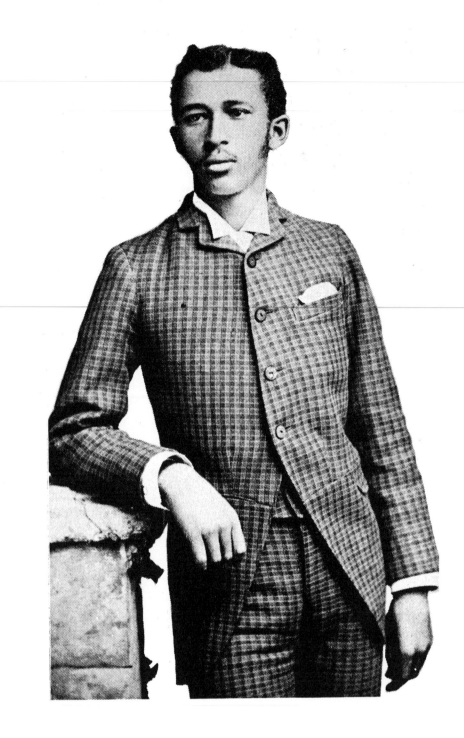

# William E. B. Du Bois

Age 19. As a junior at Fisk University.

Born February 23, 1868, in Great Barrington, Massachusetts.

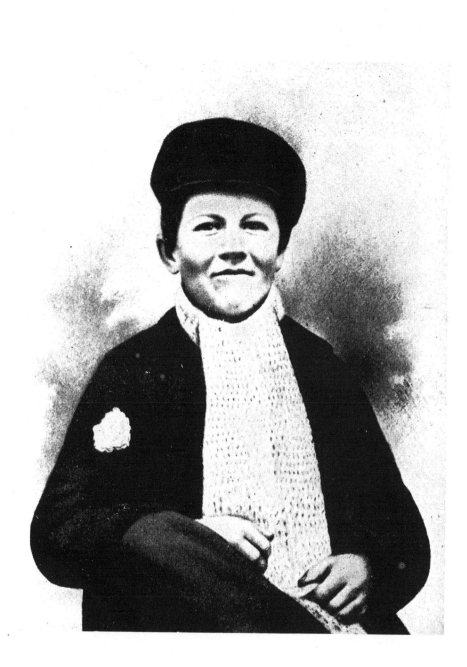

# Thomas Edison
Age 14.

Born February 11, 1847, in Milan, Ohio.

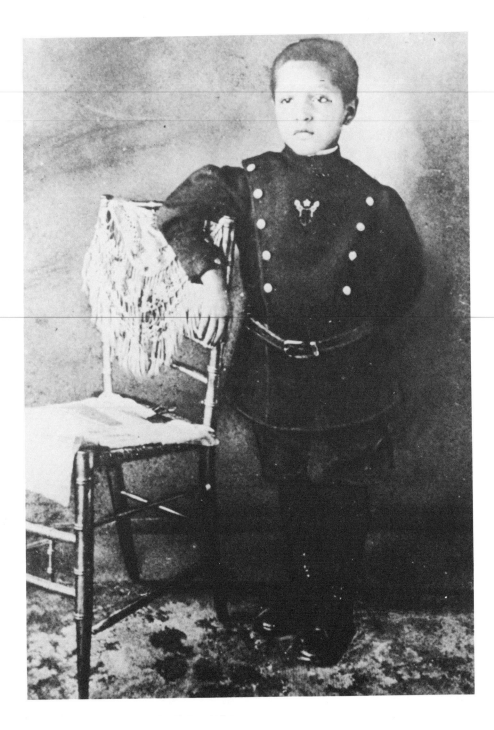

# Duke Ellington
Age 4.

Born April 29, 1899, in Washington, D.C.

BOOK WISDOM

He is not wise who from his reading draws
Nothing but floods of useless erudition.
For all his learning, life's mysterious laws
Are a closed book beyond his comprehension.
He who acquires a thorough textbook grounding
In Botany, won't hear the grass that grows
Nor will he ever teach true understanding
Who tells you all the dogma that he knows.
On, no! The germ lies hid in man's own heart.
Who seeks the art of life must look within.
Burning the midnight oil will not impart
The secret of emotion's discipline.
The man is lost who hears his own heart's voice
And spurns it, wilfully misapprehending.
Of all your words so noble and so wise
The most profound is human understanding.

(age 18)

# Friedrich Engels
About 19.

Born November 28, 1820,
in Barmen, Wuppertal, Germany.

# Werner Erhard
About 4.

Born September 5, 1935, in Philadelphia, Pennsylvania.

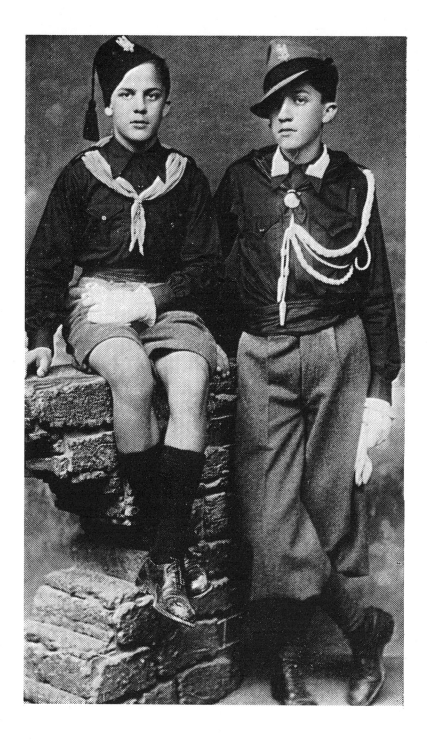

# Federico Fellini
Right, age 13. In *avanguardista* uniform,
with his brother Ricardo, as *balilla*.

Born January 20, 1920, in Rimini, Italy.

# W. C. Fields
About 15.

Born January 20, 1880, in Philadelphia, Pennsylvania.

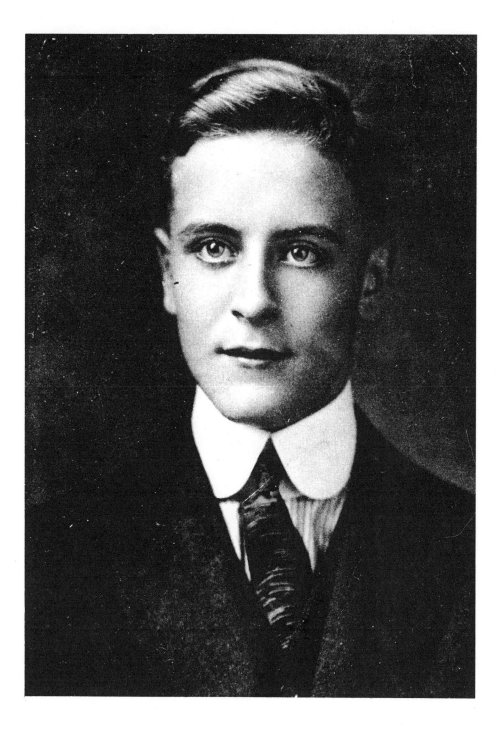

# F. Scott Fitzgerald
Age 16.

Born September 24, 1896, in Saint Paul, Minnesota.

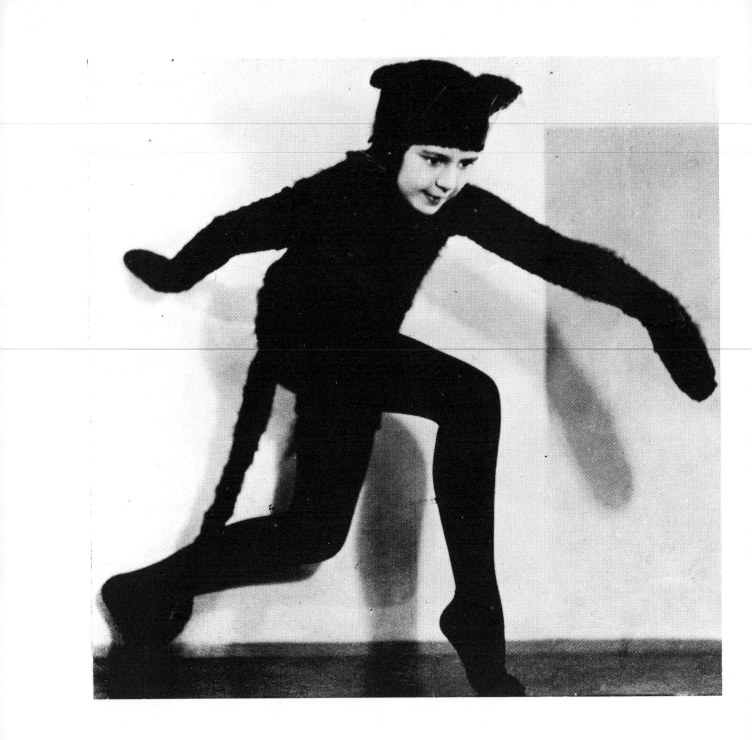

# Margot Fonteyn
About 12. In Shanghai.

Born May 18, 1919, in Reigate, Surrey, England.

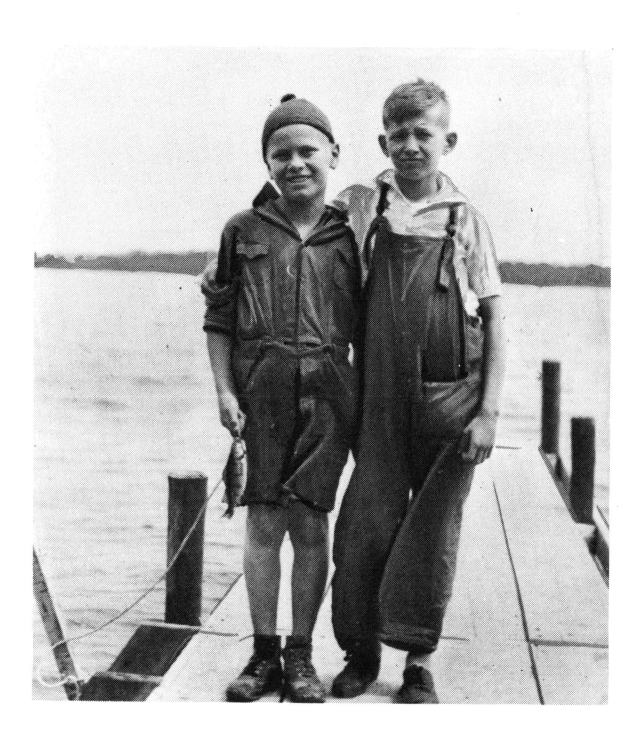

# Gerald Ford
Young Jerry (left) with fish and friend.

Born July 14, 1913, in Omaha, Nebraska.

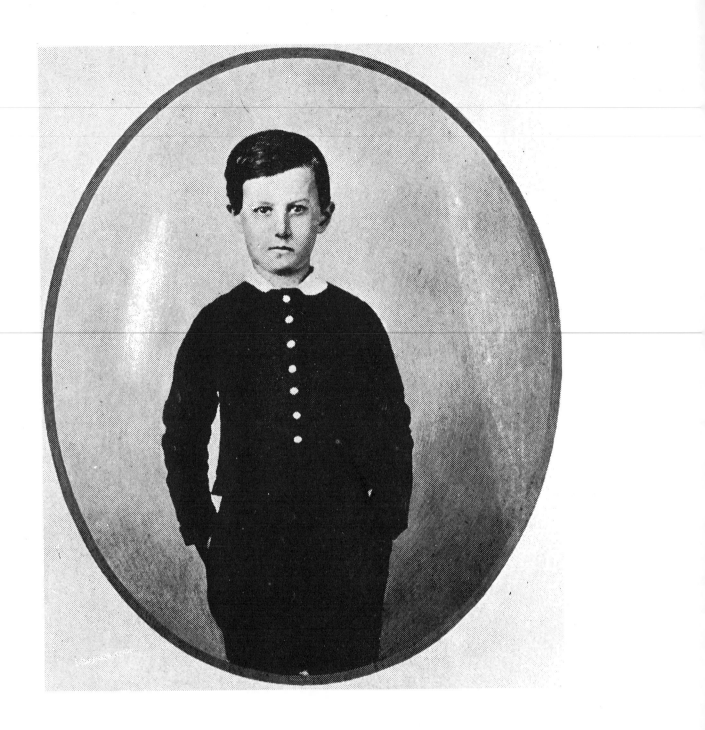

# Stephen Foster

Born July 4, 1826, in Lawrenceville (near Pittsburgh), Pennsylvania.

# Frederick the Great

Left, age 2. With his sister Wilhelmine, age 4.

Born January 24, 1712, in Berlin.

# Eva Gabor
Born February 11, 1920, in Budapest, Hungary.

# Zsa Zsa Gabor
Born February 6, 1918, in Budapest, Hungary.

# Magda Gabor
Born 1914, in Budapest, Hungary.

Eva (left), Zsa Zsa, Magda and their mother Jolie.

# Judy Garland
Seated, about 3. With her sisters Mary Jane (left) and Virginia.

Born June 10, 1922, in Grand Rapids, Minnesota.

# Paul Gauguin
Age 2.

Born June 7, 1848, in Paris, France.

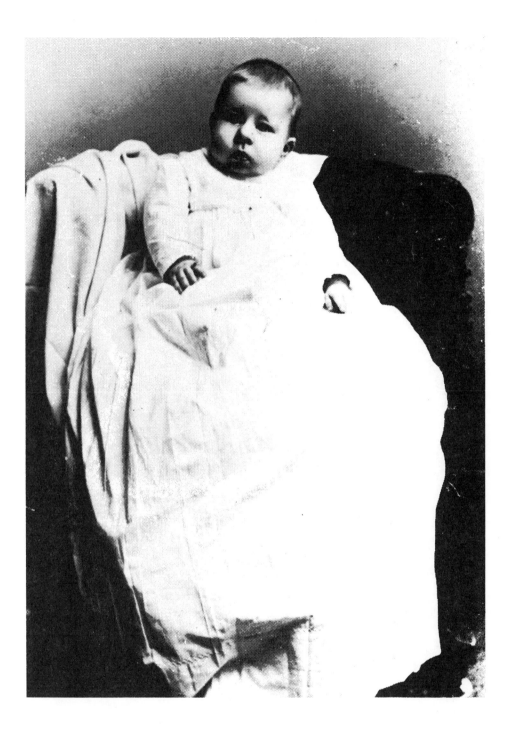

# J. Paul Getty
Age 5 months.

Born December 15, 1892, in Minneapolis, Minnesota.

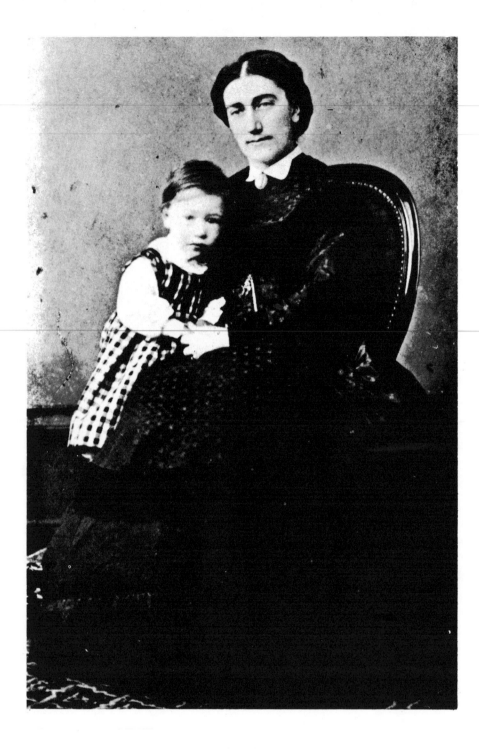

# André Gide

Age 4. With his mother Juliette.

Born November 22, 1869, in Paris, France.

# William Schwenck Gilbert

Gilbert's 1869 drawing of himself as an infant:
used as title page illustration for his *Bab Ballads*.

In 1852 William contracted a serious case of typhoid, which left him quite weak and temporarily bald. As part of his convalescence he was taken by his parents to the Continent, where in Paris, in November, they witnessed the gala coronation parade of Napoleon III and the Empress Eugenie. After the event young William retired to his hotel room and emerged an hour later with this, his earliest surviving poem:

When the horses, white with foam,
Drew the Empress to her home
From the place whence she did roam,
The Empress she did see
The Gilbert Familee.

To the Emperor she said:
'How beautiful the head
Of that youth of gallant mien,
Cropped so neat and close and clean —
Though I own he's rather lean'.

Said the Emperor: 'It is!
And I never saw a phiz
More wonderful than 'is'.

(age 16)

Born November 18, 1836, in London, England.

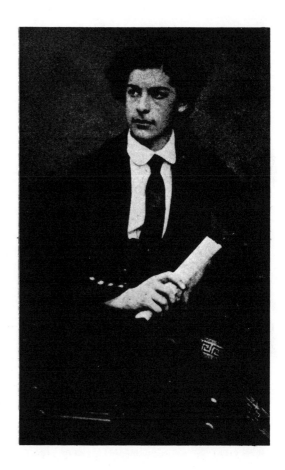

# Arthur Sullivan

Age 16.
Born May 13, 1842, in London, England.

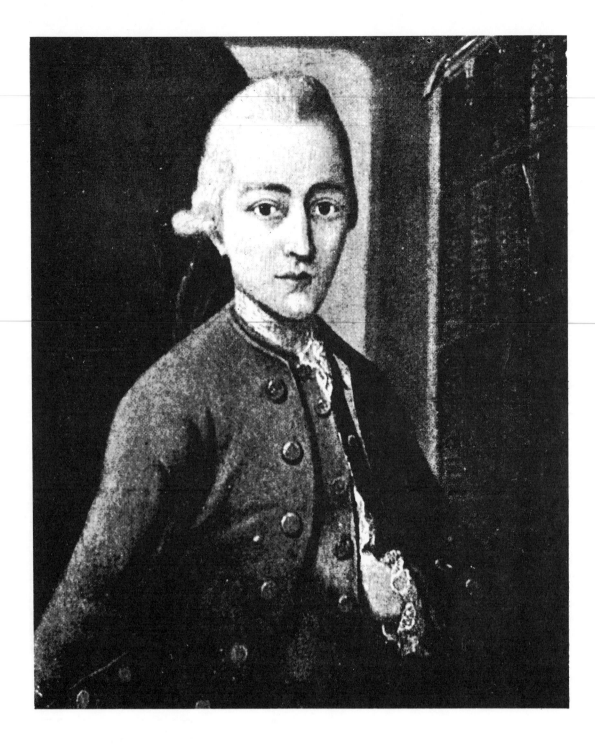

# Johann Wolfgang von Goethe
Age 16.

Born August 28, 1749, in Frankfurt-on-Main.

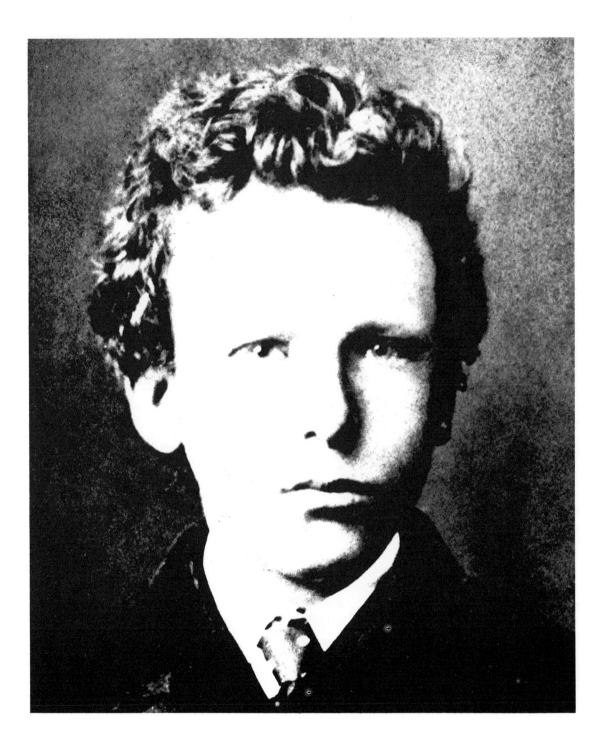

# Vincent van Gogh
About 13.

Born March 30, 1853, in Zundert, Brabant, The Netherlands.

# Evonne Goolagong
At Willoughby High School for Girls in Sydney.

Born July 31, 1951, in Griffith, New South Wales, Australia.

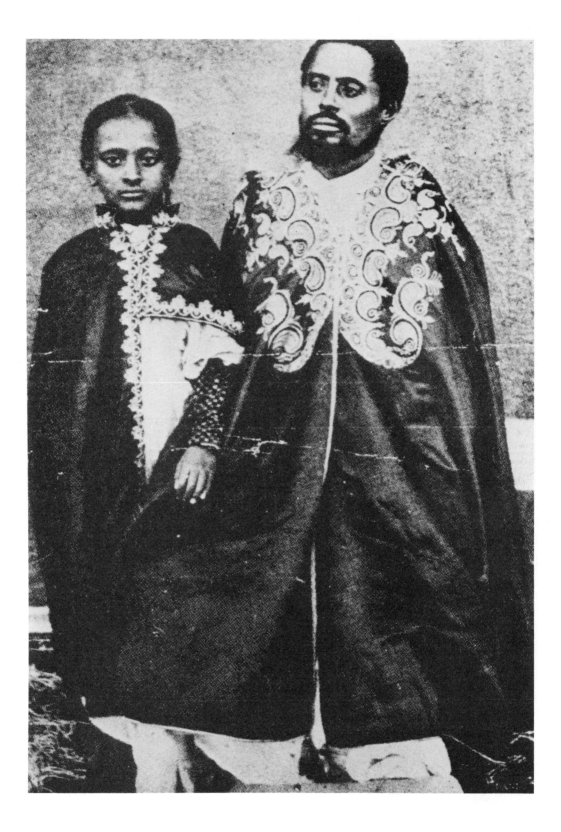

# Haile Selassie

About 7. With his father Ras Makonnen.

Born July 23, 1892, in Ejärsa Goro (near Harar), Ethiopia.

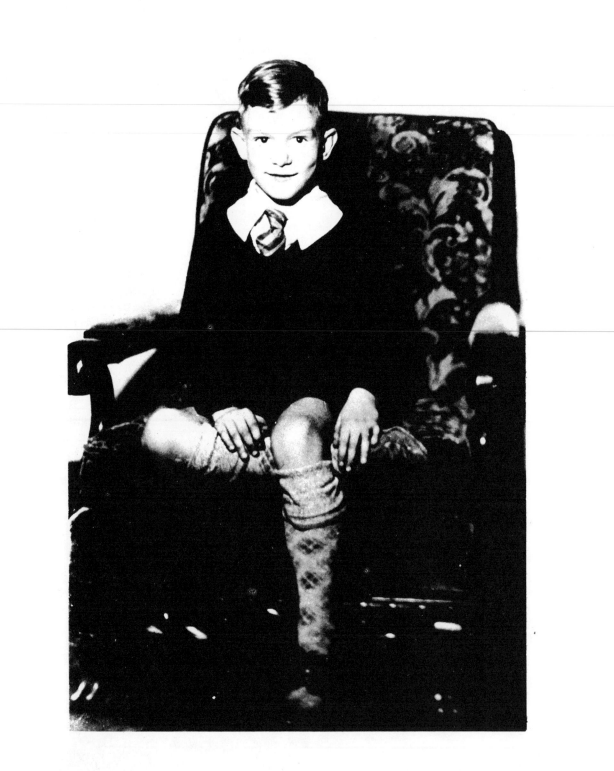

# Hugh Hefner
Age 8.

Born April 9, 1926, in Chicago, Illinois.

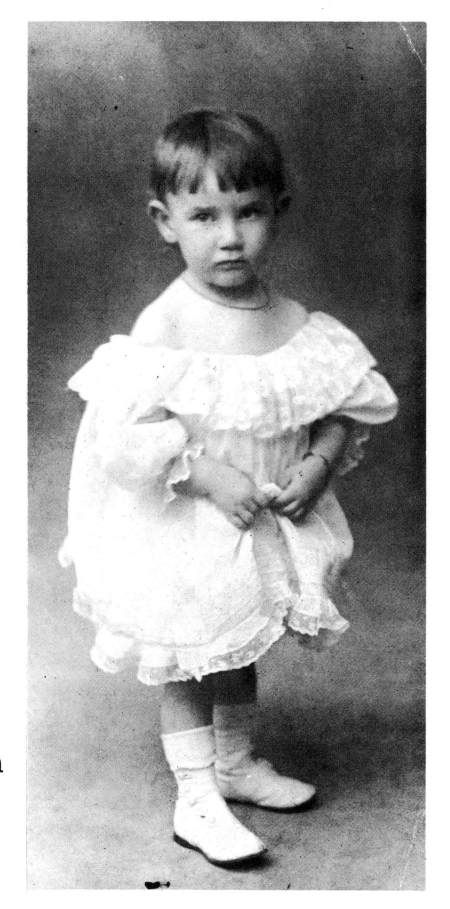

# Lillian Hellman

Born June 20, 1905,
in New Orleans, Louisiana.

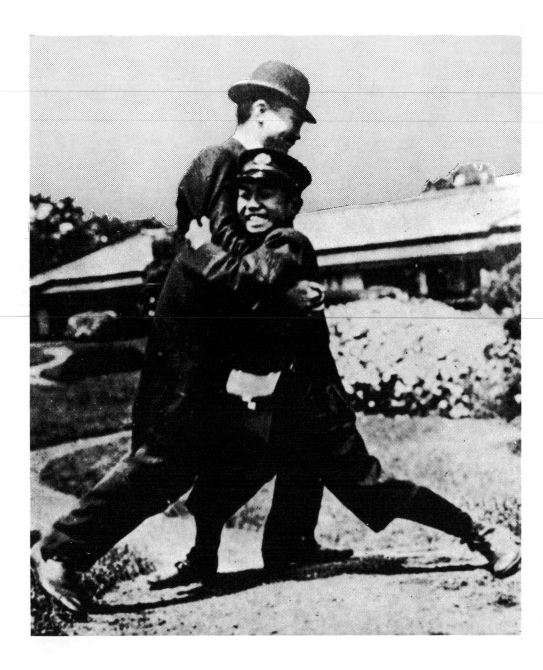

# Hirohito

Age 9. Wrestling with his tutor.

Born April 29, 1901, in Tokyo, Japan.

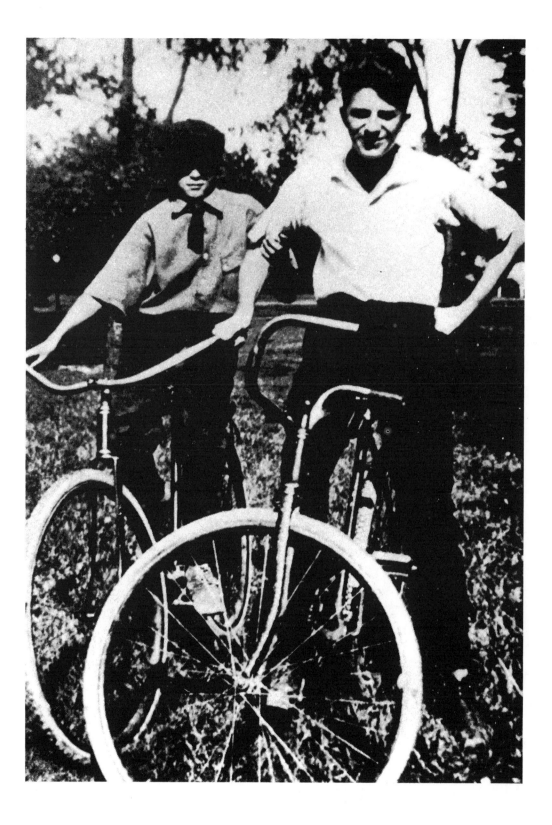

# Bob Hope
On right.

Born May 29, 1903, in Eltham, London, England.

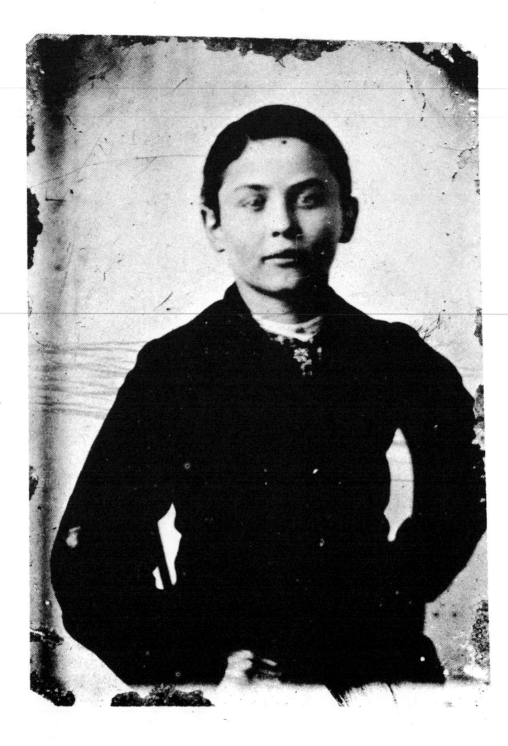

# Harry Houdini
About 13.

Born March 24, 1874, in Budapest.

# Howard Hughes

Age 15. From class photograph, Fessenden School, West Newton, Massachusetts.

Born December 24, 1905, in Houston, Texas.

# E. Howard Hunt

Age 2.

Born October 9, 1918, in Hamburg, New York.

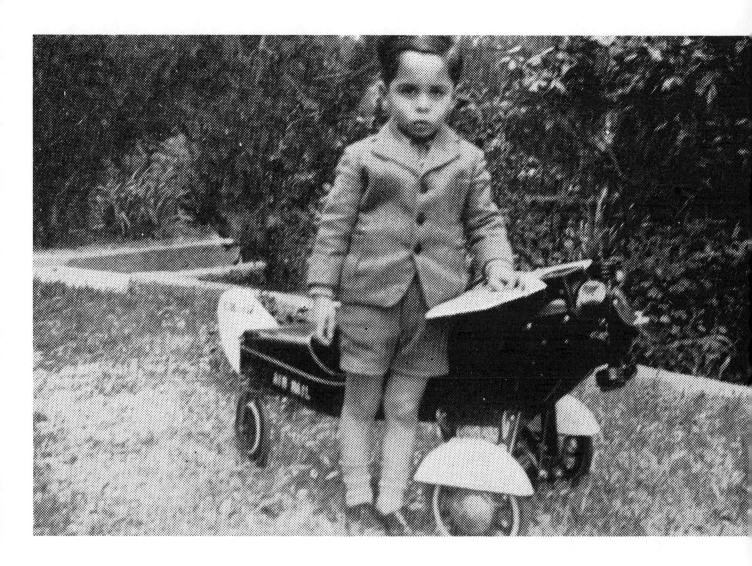

# King Hussein ibn Talal

With his first private airplane.

Born November 14, 1935, in Amman, Jordan (then Transjordan).

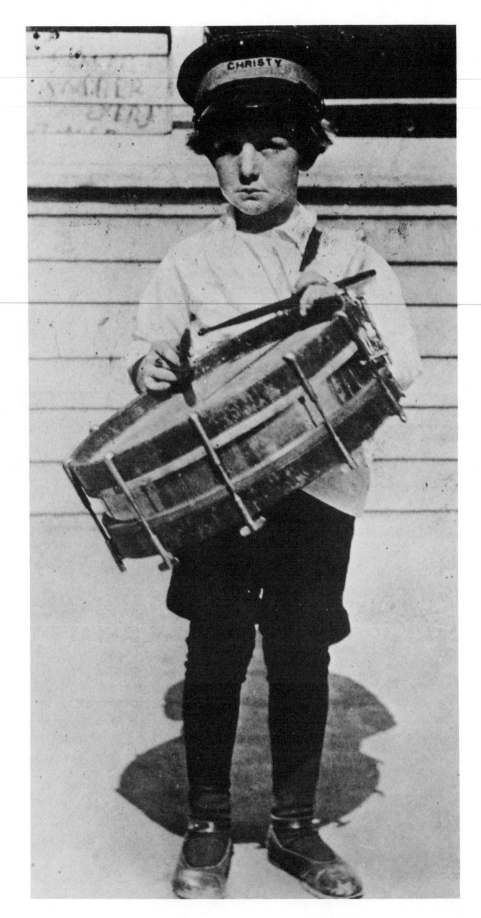

## Harry James

Age 7. As drummer in Christy
Brothers Circus second band.

Born March 15, 1916,
in Albany, Georgia.

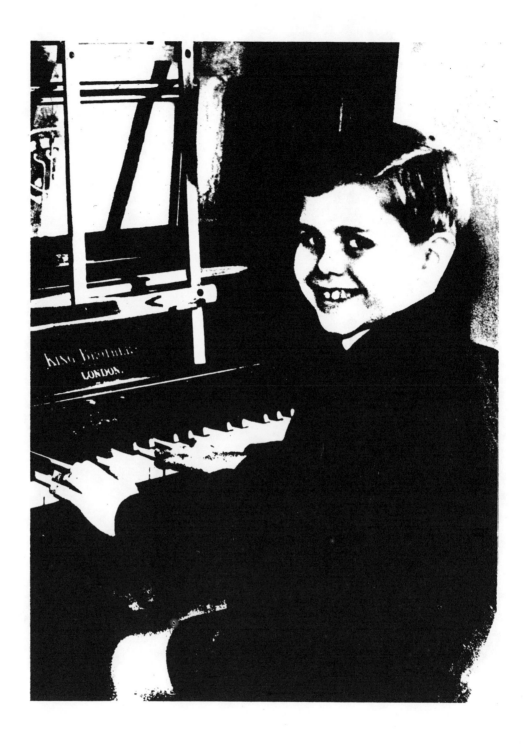

# Elton John
Age 9.

Born March 25, 1947, in Pinner, Middlesex, England.

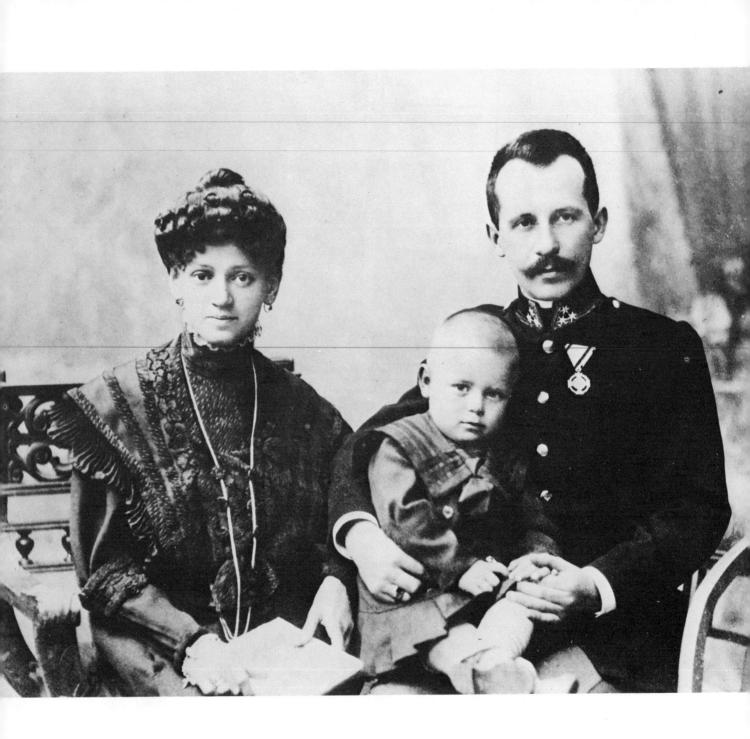

# Pope John Paul II
With his mother Emilia and father Karol Wojtyla.

Born May 18, 1920, in Wadowice (near Cracow), Poland.

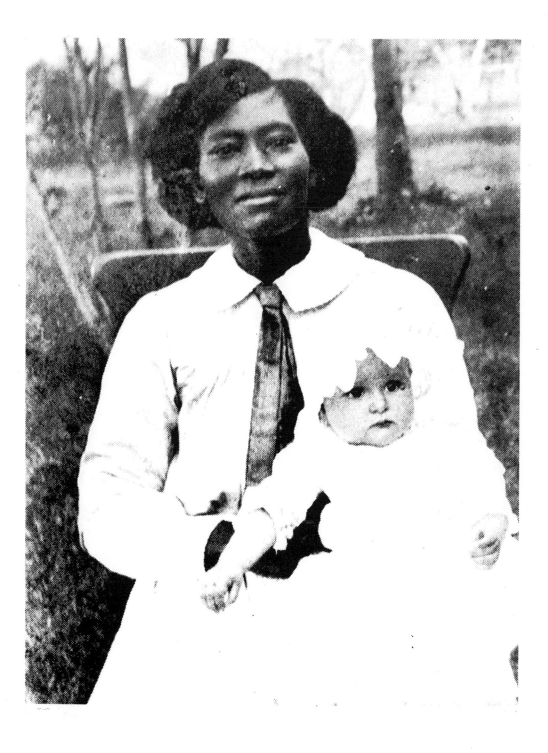

# Lady Bird Johnson
With her nursemaid Alice Tittle.

Born December 22, 1912, near Karnack, Texas.

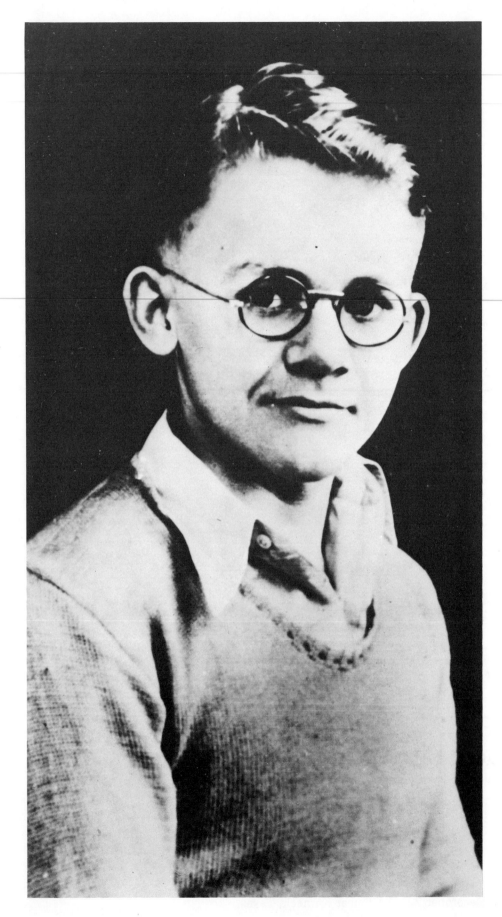

## James Jones

Born November 6, 1921,
in Robinson, Illinois.

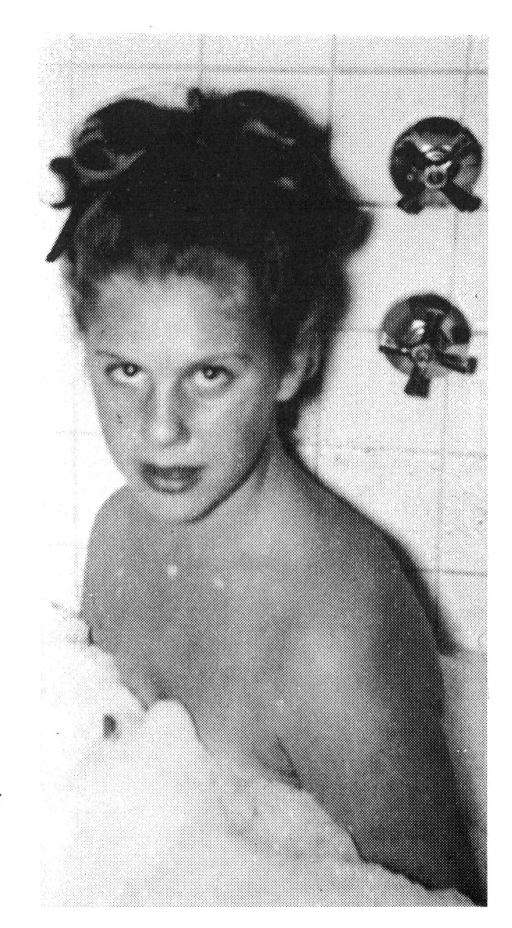

# Erica Jong
Age 13.

Born March 26, 1942,
in New York City.

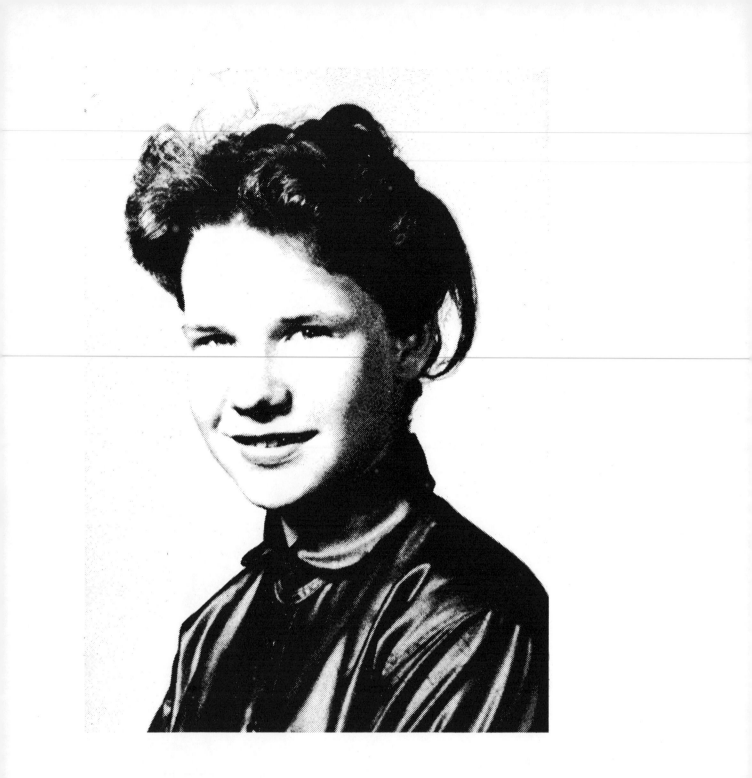

# Janis Joplin
Inscribed "To Mom and Dad, From your daughter, Janis."

Born January 19, 1943, in Port Arthur, Texas.

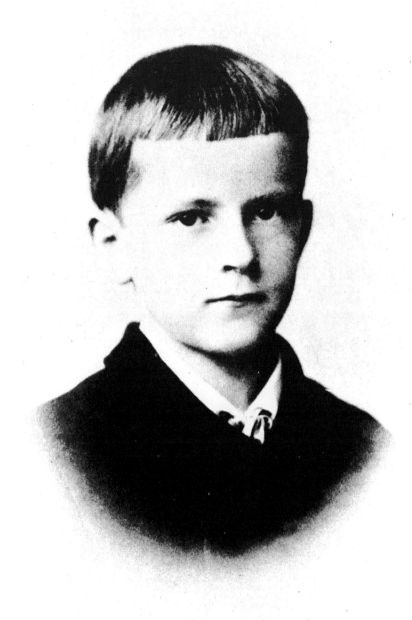

# Carl Jung
Age 6.

Born July 26, 1875, in Kesswill, Thurgau, Switzerland.

# Boris Karloff
About 5. In school uniform.

Born November 23, 1887, in Dulwich, London, England.

# John Keats
About 14.

Born October 31, 1795, in London, England.

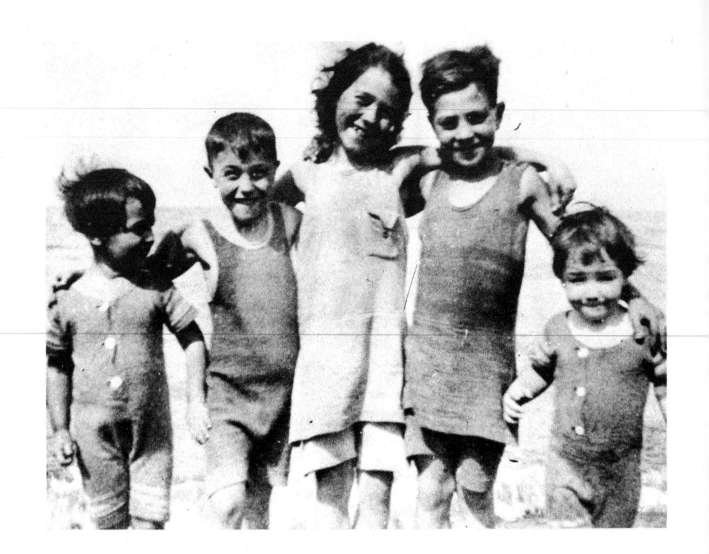

# Gene Kelly

Louise, Gene, Harriet Joan, James, and Fred: brothers and sisters.

Born August 3, 1912, in Pittsburgh, Pennsylvania.

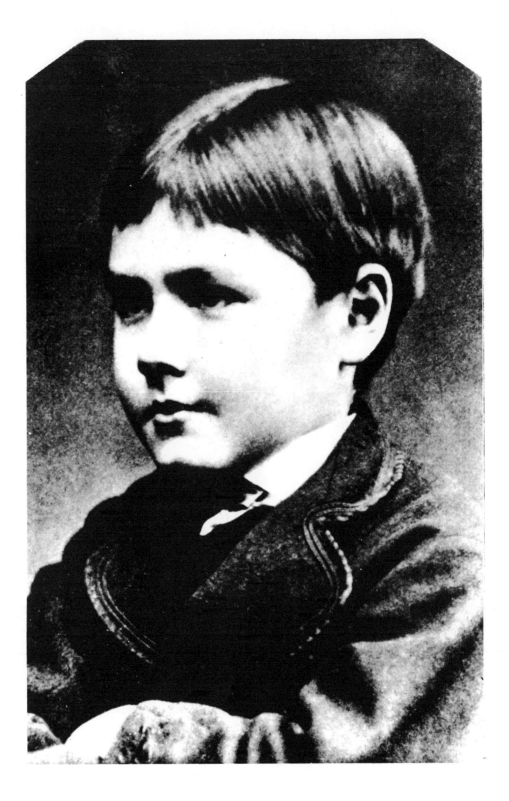

# Rudyard Kipling
About 6.

Born December 10, 1865, in Bombay, India.

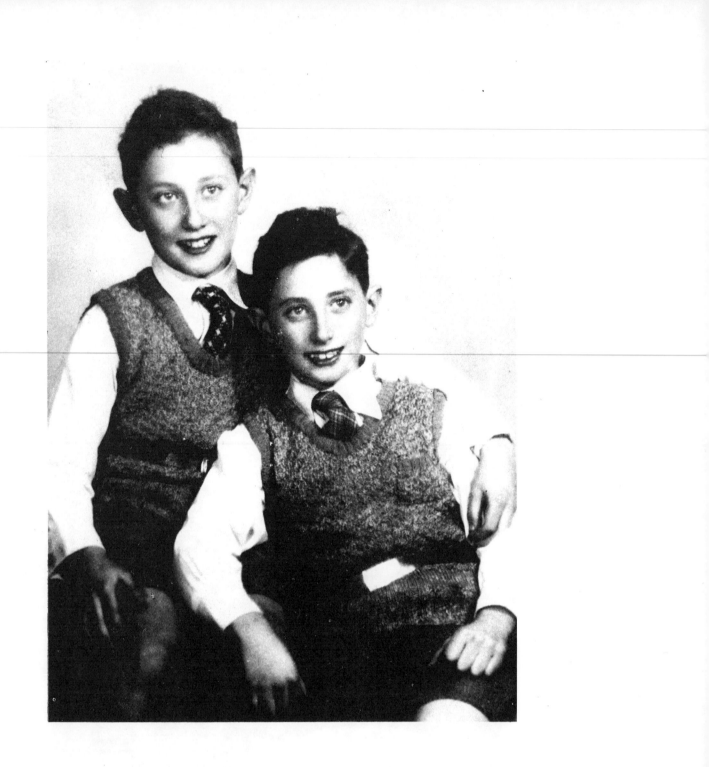

# Henry Kissinger

Left, age 11. With his younger brother Walter.

Born May 27, 1923, in Fürth, Bavaria.

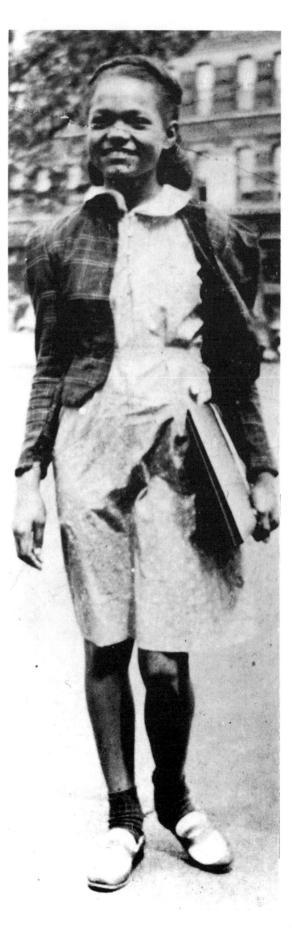

# Eartha Kitt

Age 11. As New York City
grade school student.

Born January 26, 1928, in North, South Carolina.

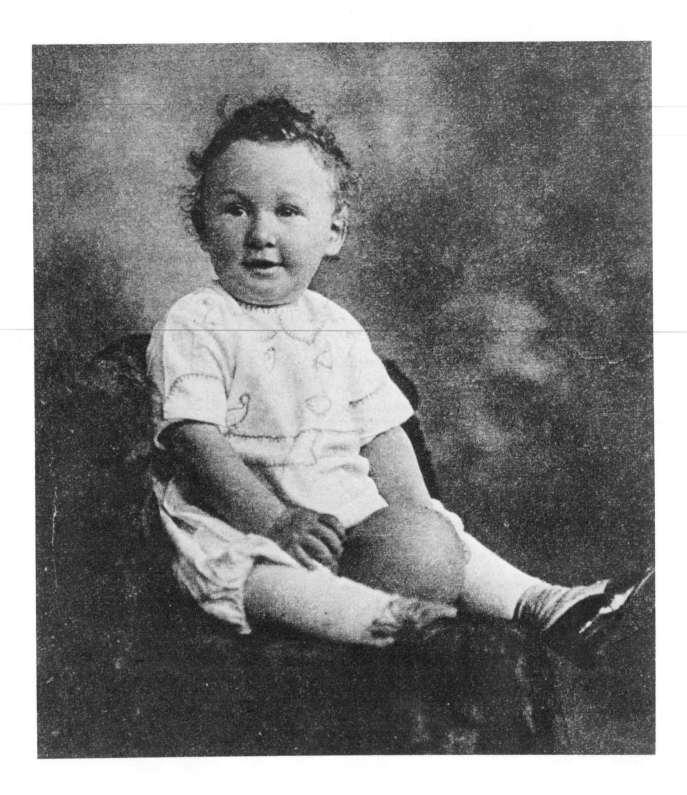

# Edward Koch

Age 2.

Born December 12, 1924, in New York City.

# Alfried Krupp

Age 5. With his mother Bertha and father Gustav,
rehearsing for the Krupp centennial tournament.

Born August 13, 1907, in Essen, Germany.

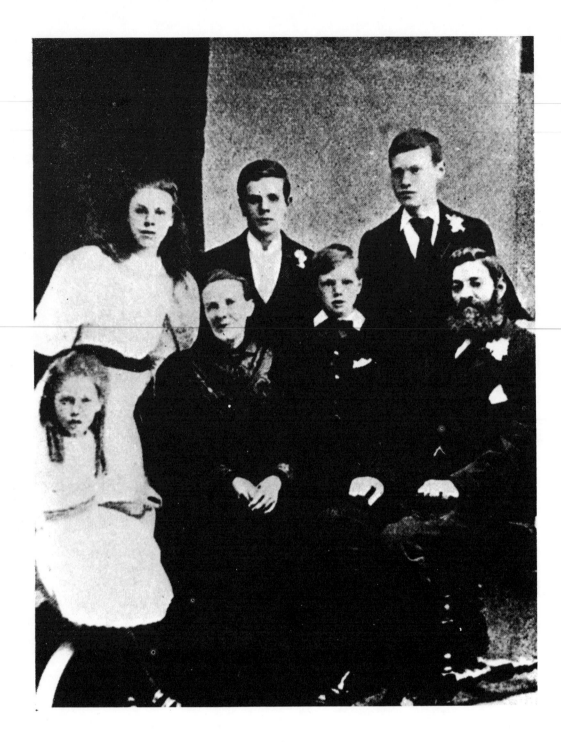

# David Herbert Lawrence

Between his mother Lydia and father Arthur John, with sisters Ada (bottom) and Emily, and brothers George (left) and Ernest.

Born September 11, 1885, in Eastwood, Nottinghamshire, England.

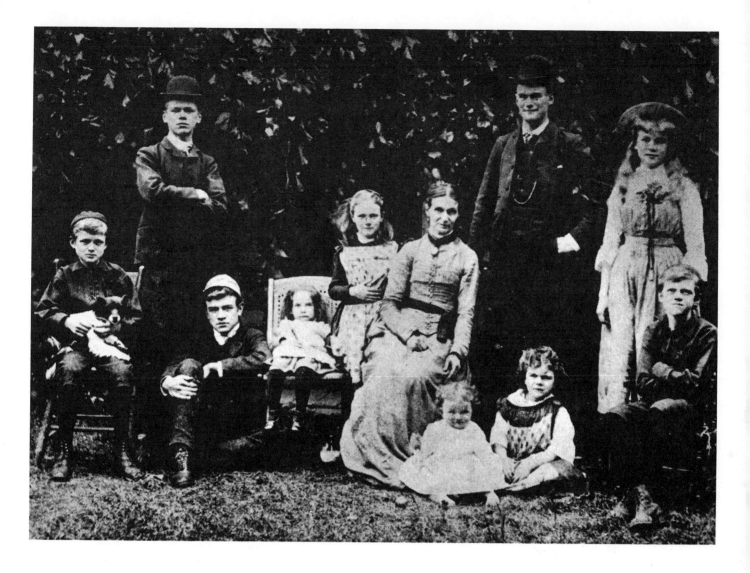

# Stephen Leacock

Third from left, about 17. With his family outside their Sutton, Ontario, farmhouse.

Born September 30, 1869, in Swanmore, Hampshire, England.

# Edward Lear

Age 19. Self-portrait drawn as part of a letter.

Born May 12, 1812, in Holloway (near London), England.

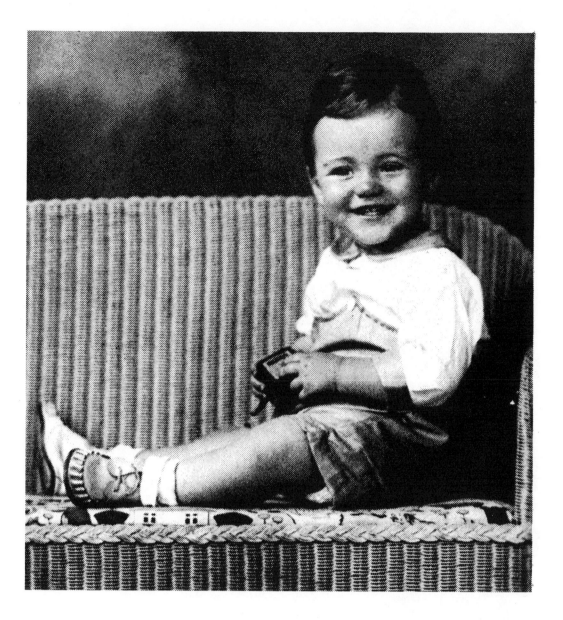

# Jack Lemmon
Age 18 months.

Born February 8, 1925, in Newton, Massachusetts.

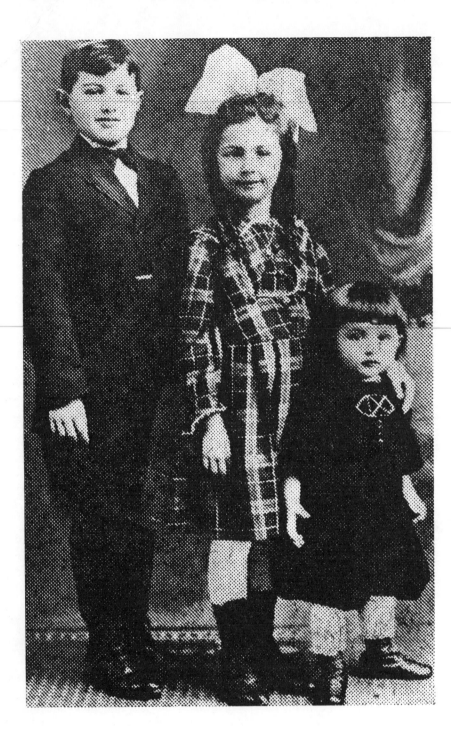

# Liberace

Right, age 2. With his brother George and sister Angie.

Born May 16, 1919, in West Allis, Wisconsin.

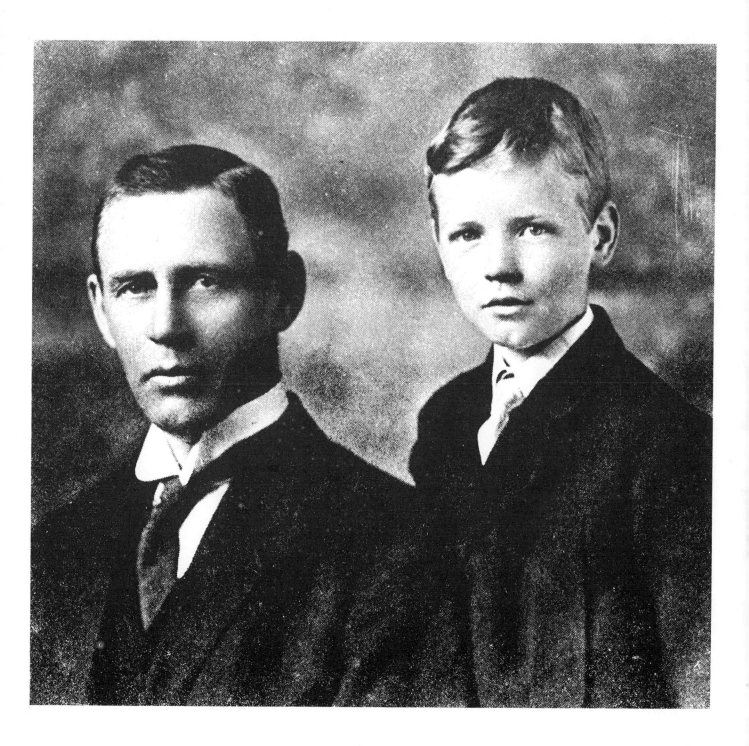

# Charles A. Lindbergh
Age 8. With his father, Congressman Charles A. Lindbergh, Sr., of Minnesota.

Born February 4, 1902, in Detroit, Michigan.

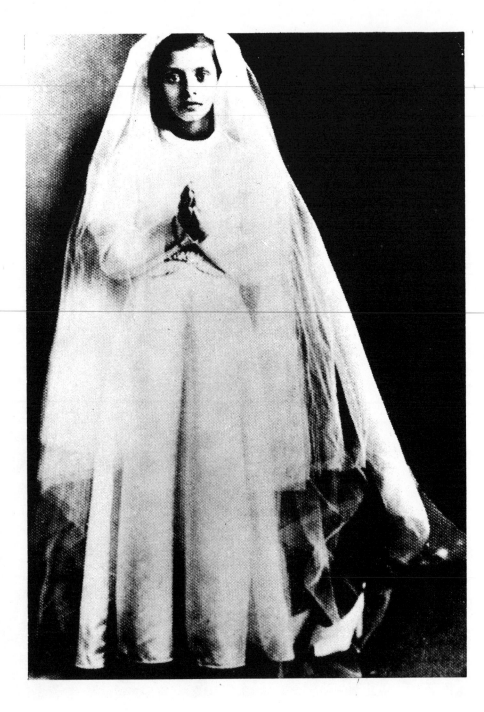

# Sophia Loren
Age 7. At First Communion.

Born September 20, 1934, in Rome, Italy.

Questions from dictation by her tutor.
Answers in her "Complete Composition Book."

Name? Amy Lowell.
Resedence? Brookline.
What is your favorite moral caracterestic? Self controll.
Which one do you most dislike? deceat.
What is your favorite extrravegence? [unanswered]
What is your favorite exercise? books.
Who is your favorite hero in American history? Benjamin Franklin.
Who in the history of other countrys? Alfred the Great.
What caracter (male) in all history do you most dislike? Nepolian Bonaparte.
Who is your favorite heroin in American history? Barbera Friche.
Who in the history of other countries? Grace Dar Josephine.
What caracter (female) in all history do you most dislike? Joan of Arc.
What are your reasons for your reasons for your likes and dislikes [?] Joseph's husband
    illtreated her [.] Joan of Arc was too masculin
Who is your favorite novelist among men? Thackeray
Who among women? Louisa. May. Alcott.
What is your favorite work of fiction? Little Women.
Who is your favorite hero in fiction? Diamond in 'At the Back of the North Wind.'
Who the most disliked? Steve (in 'Rose in Bloom')
Who is your favorite heroin? Jo (in 'Little Women.')
Who the one most disliked? Aunt Mira (in 'Eight Cousins')
Who is your favorite poet? James Russel Lowell.
What [is] your favorite poem? The vision of Sir Launfall.
What is your idea [of] misery? Not to be allowed to tobbogan.
What is your idea of happyness? To be loved.
What quality do you like best in a man? Manliness.
What do you most dislike? Cowardliness.
What quality doe you like most in a woman? Modesty.
What do you most dislike? imodesty.
What six books (Bible excepted) would you most desire to have with you if you were
    cast on a desert island? Little Women, Webebsters unabridged Dictionary, Moon
    folk, Boys a[t] Chequasset, Marco Pauls adventures on the Erie Canal, & At the
    back of the North Wind.

(about 14)

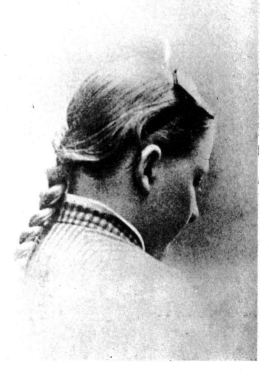

# Amy Lowell
Age 8.

Born February 9, 1874,
in Brookline, Massachusetts.

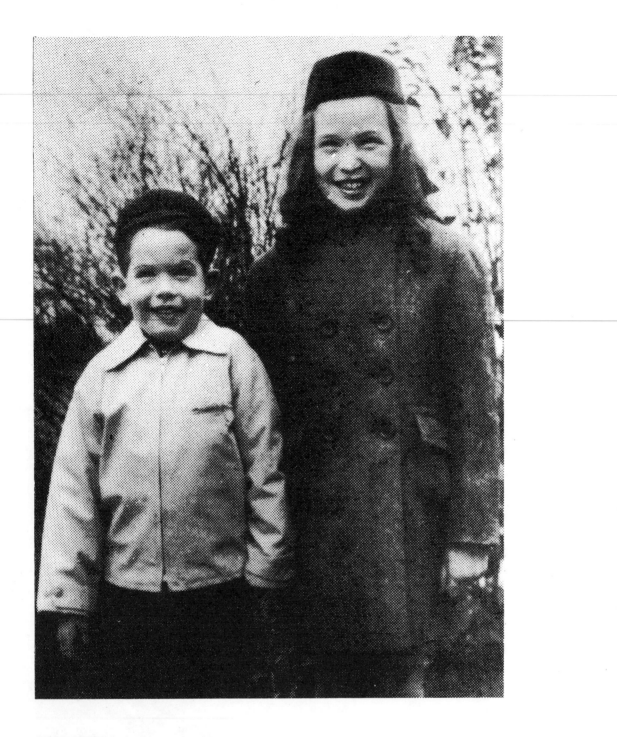

## Shirley MacLaine
Born April 24, 1934, in Richmond, Virginia.

## Warren Beatty
Born March 30, 1938, in Richmond, Virginia.

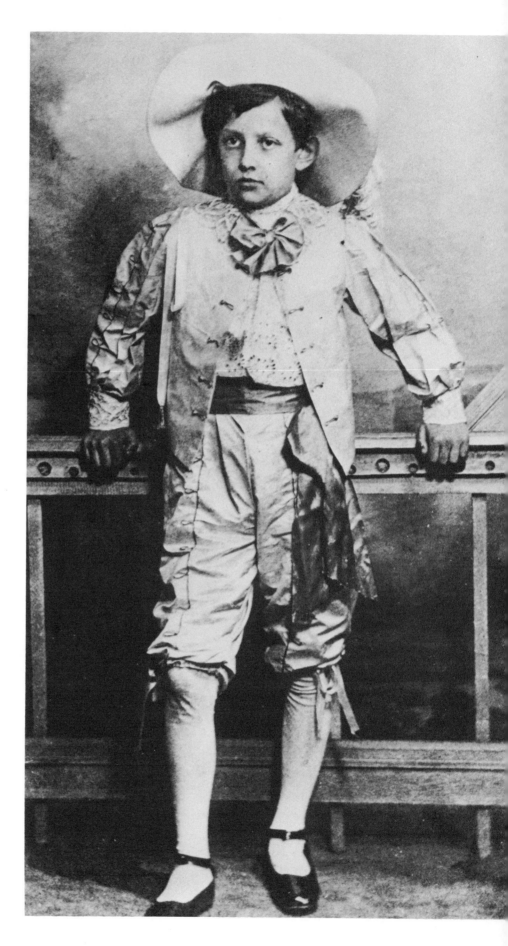

# André Malraux

Born November 3, 1901,
in Paris, France.

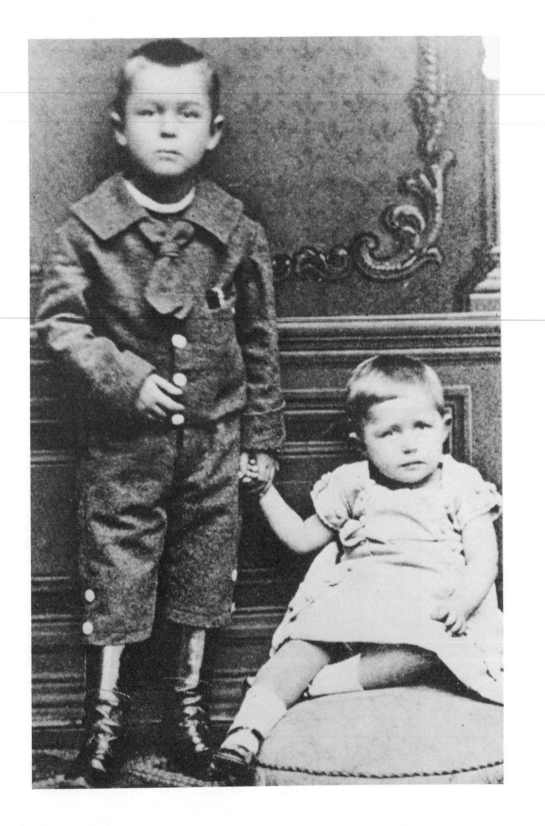

# Thomas Mann

About 6. With his sister Julia.

Born June 6, 1875, in Lübeck, Germany.

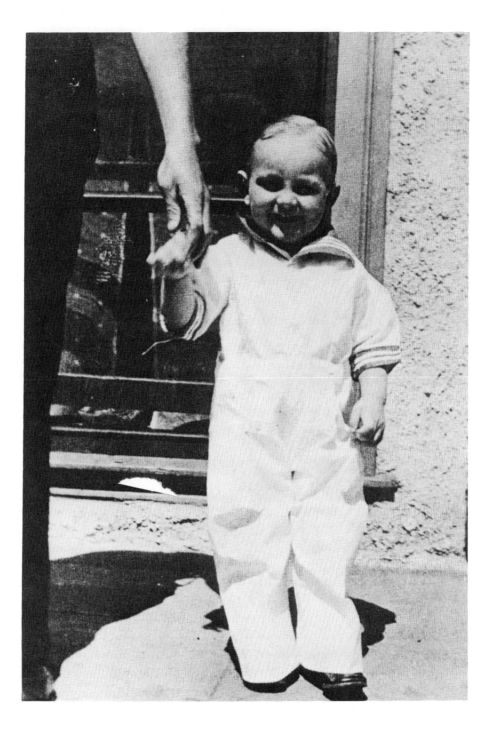

# Rod McKuen
About 3.

Born April 29, 1933, in Oakland, California.

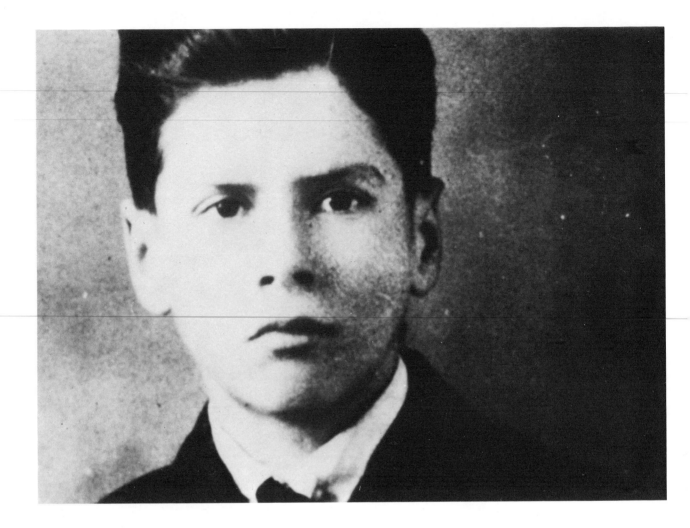

# Marshall McLuhan
Age 9.

Born July 21, 1911, in Edmonton, Alberta, Canada.

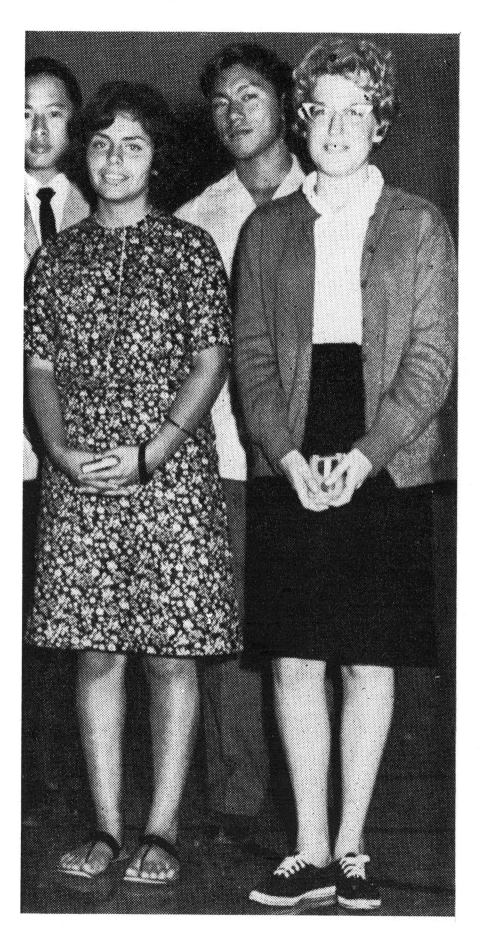

# Bette Midler

Right. As high school senior.

Born December 1, 1945,
in Paterson, New Jersey.

from

## ON THE DEATH OF A FAIR INFANT
## DYING OF A COUGH

O FAIREST Flower, no sooner blown but blasted,
Soft silken Primrose fading timelessly,
Summer's chief honour, if thou hadst outlasted
Bleak Winter's force that made thy blossom dry;
For he, being amorous on that lovely dye
    That did thy cheek envermeil, thought to kiss,
But killed, alas! and then bewailed his fatal bliss.

But oh! why didst thou not stay here below
To bless us with thy heaven-loved innocence,
To slake his wrath whom sin hath made our foe,
To turn swift-rushing black perdition hence,
Or drive away the slaughtering pestilence,
    To stand 'twixt us and our deservèd smart?
But thou canst best perform that office where thou art.

(age 17)

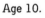

# John Milton
Age 10.

Born December 9, 1608, in London, England.

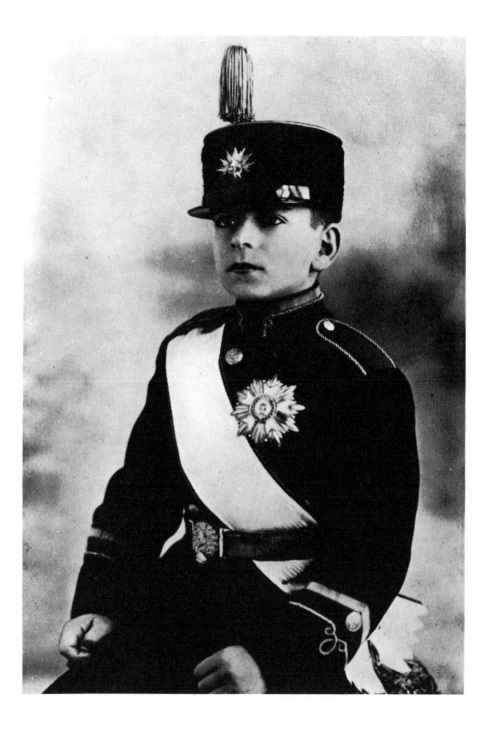

# Shah Mohammed Reza Pahlevi
As Crown Prince.

Born October 26, 1919, in Teheran.

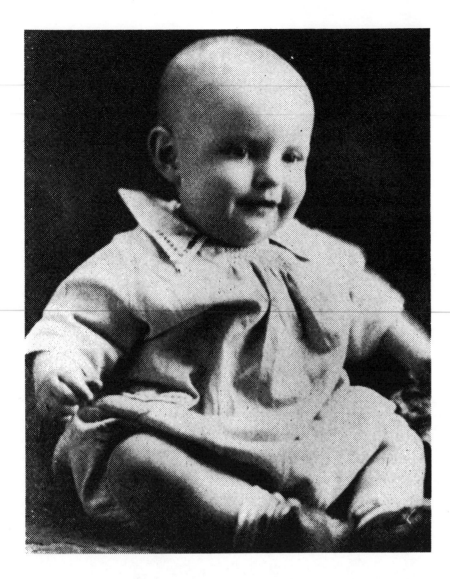

# Walter Mondale

Born January 5, 1928, in Ceylon, Minnesota.

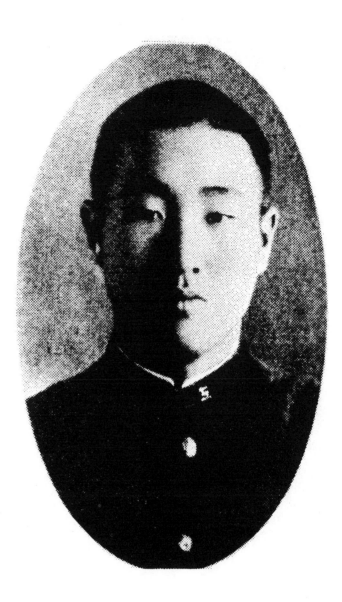

# Sun Myung Moon

As high school student.

Born January 6, 1920,
in Chongju-Gun, North Korea.

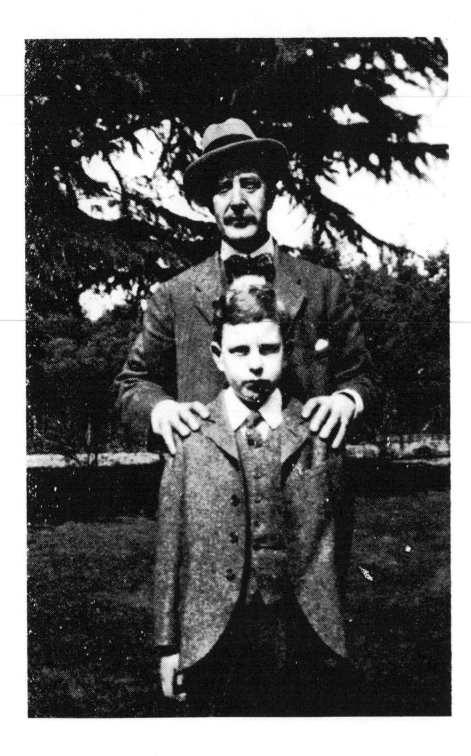

# Robert Morley

About 8. With his father.

Born May 26, 1908, in Semley, Wiltshire, England.

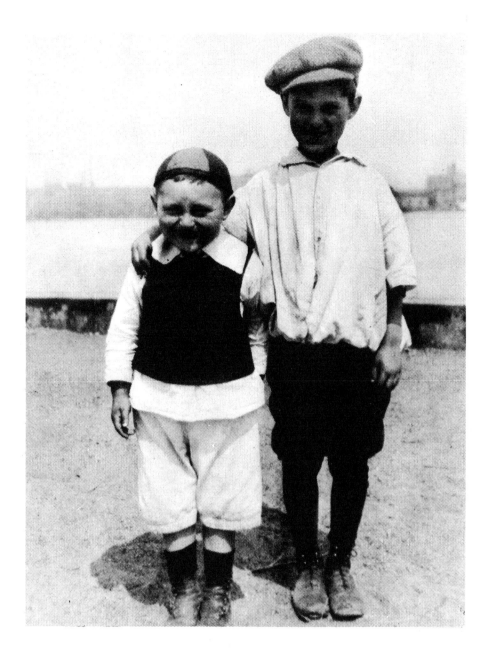

# Zero Mostel

With his younger brother Velvel.

Born February 28, 1915, in Brooklyn, New York.

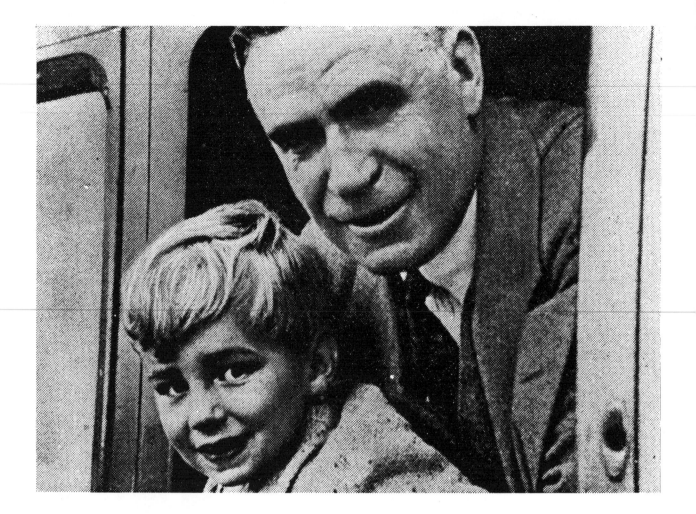

# Rupert Murdoch
Age 5. With his father Sir Keith.

Born March 11, 1931, in Melbourne, Australia.

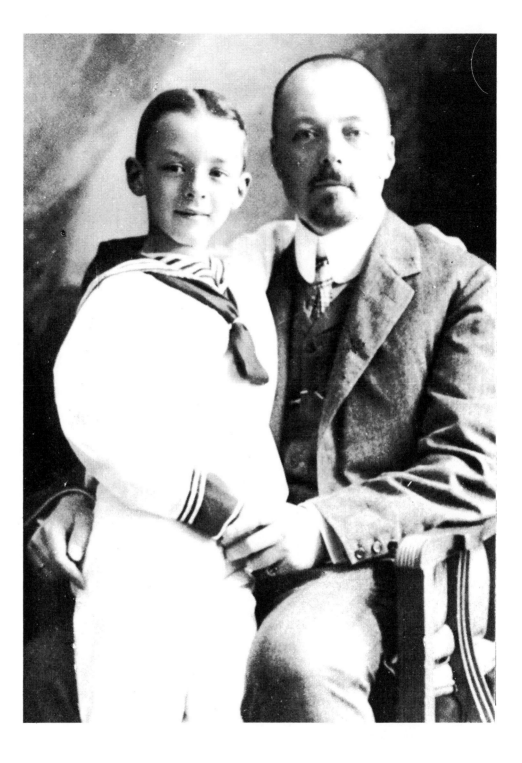

# Vladimir Nabokov
Age 7. With his father Vladimir Dmitrievich.

Born April 22, 1899, in Saint Petersburg, Russia.

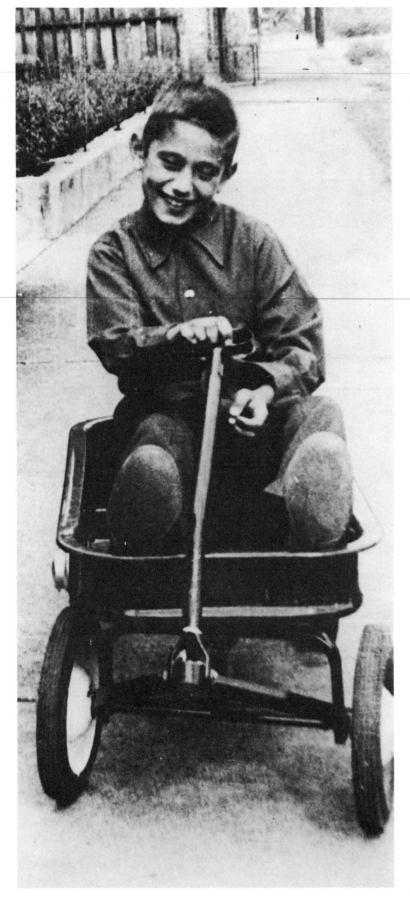

# Joe Namath
Age 6.

Born May 31, 1943,
in Beaver Falls, Pennsylvania.

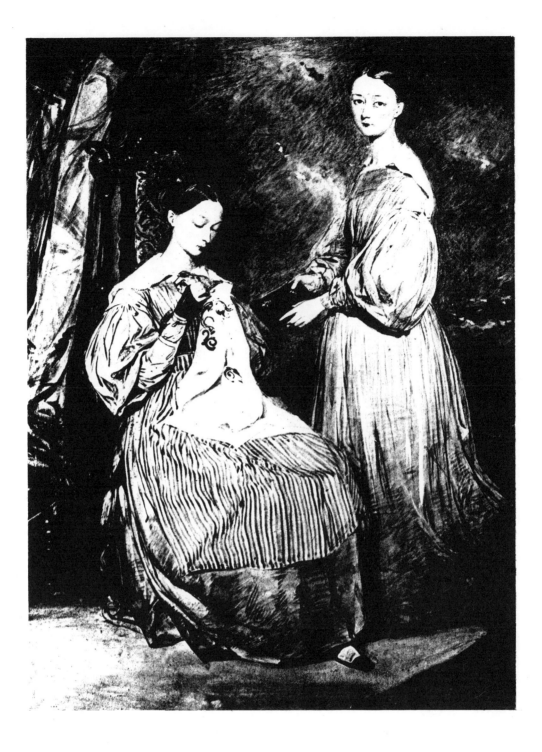

# Florence Nightingale
Seated, age 16. With her older sister Parthenope.

Born May 12, 1820, in Florence, Italy.

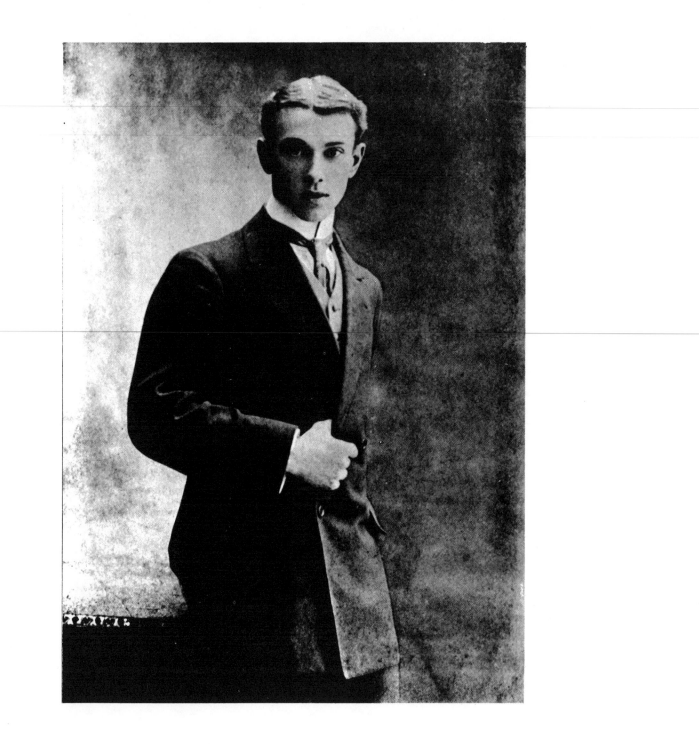

# Vaslav Nijinsky
Age 17.

Born March 12, 1890, in Kiev, Ukraine, Russia.

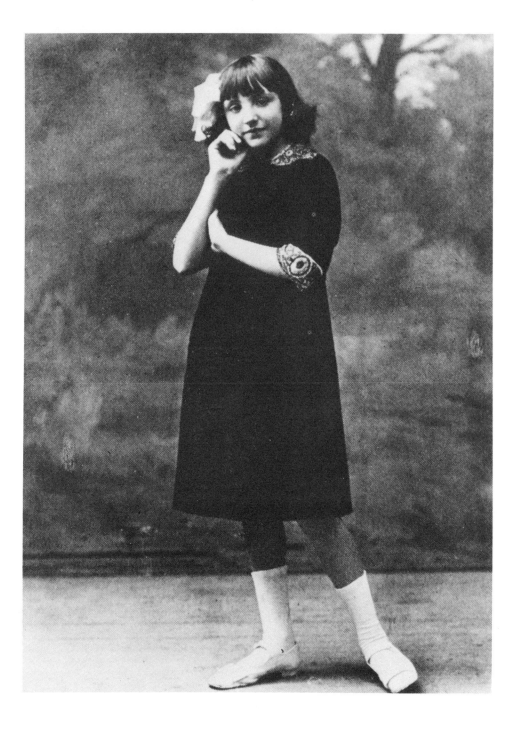

Age 9.

Born February 21, 1903, in Paris, France.

# Phil Ochs
Age 12.

Born December 19, 1940, in El Paso, Texas.

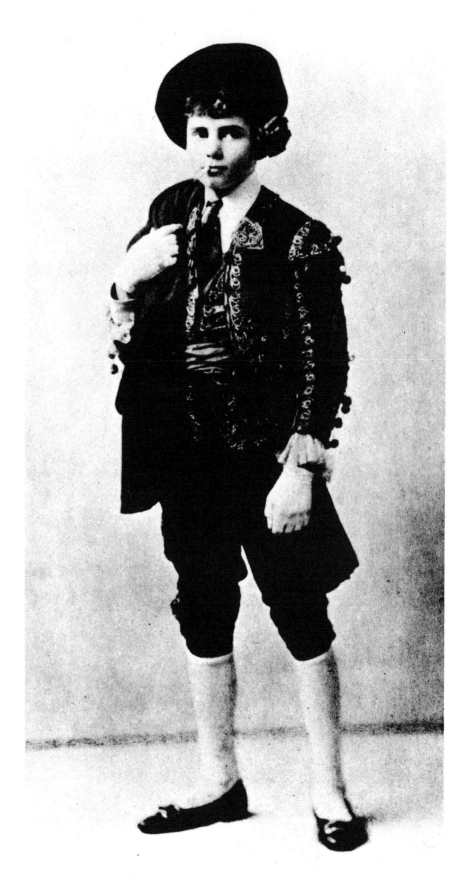

# Laurence Olivier

Age 11. As a toreador.

Born May 22, 1907,
in Dorking, Surrey, England.

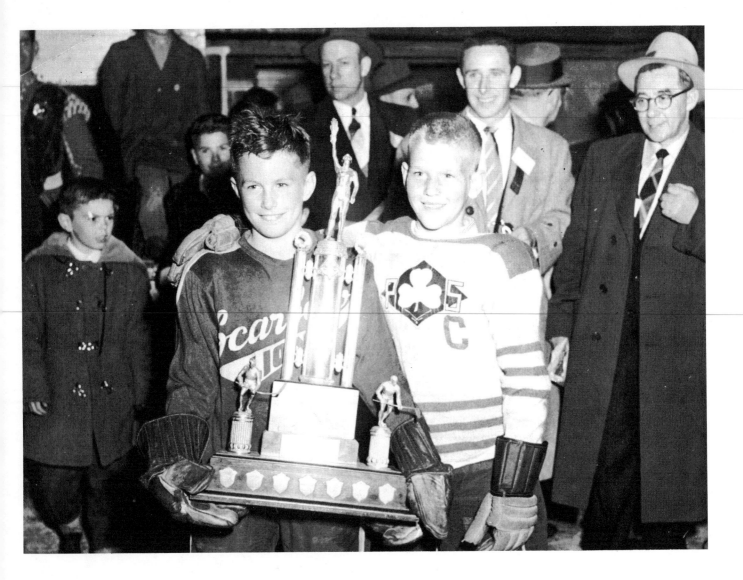

# Bobby Orr

Right, about 13. Sharing Ontario Bantam play-off honors
with the captain of the Scarboro team, Syl Apps, Jr.

Born March 20, 1948, in Parry Sound, Ontario, Canada.

Dolly Parton
Age 8.

Born January 19, 1946, in Sevierville, Tennessee.

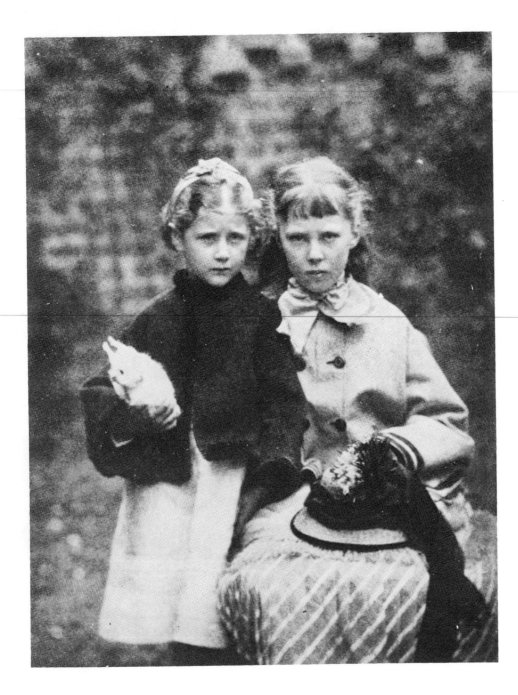

# Beatrix Potter
Holding toy rabbit, with her cousin Alice Burton.

Born July 28, 1866, in London, England.

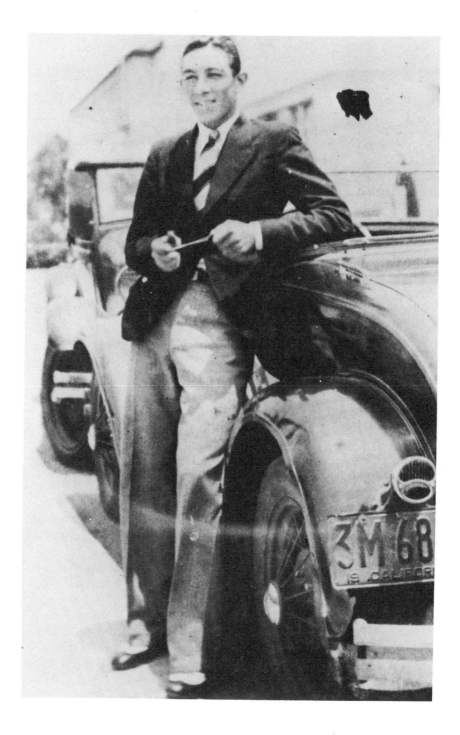

# Anthony Quinn

Age 17.

Born April 15, 1915, in Chihuahua, Mexico.

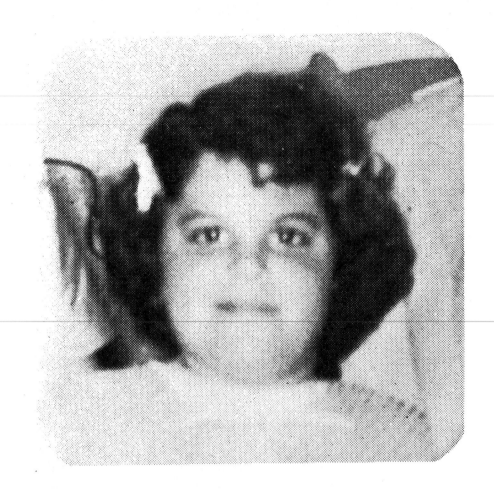

# Gilda Radner
Age 9.

Born June 28, 1946, in Detroit, Michigan.

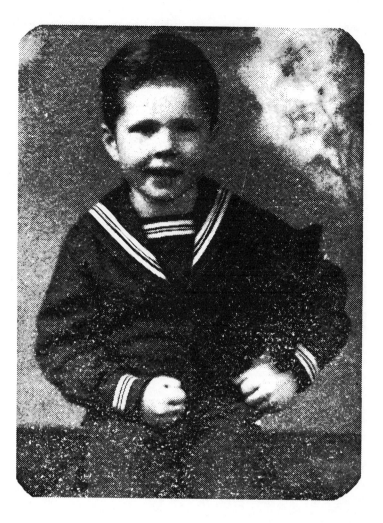

# Robert Redford
Age 4.

Born August 18, 1937, in Santa Monica, California.

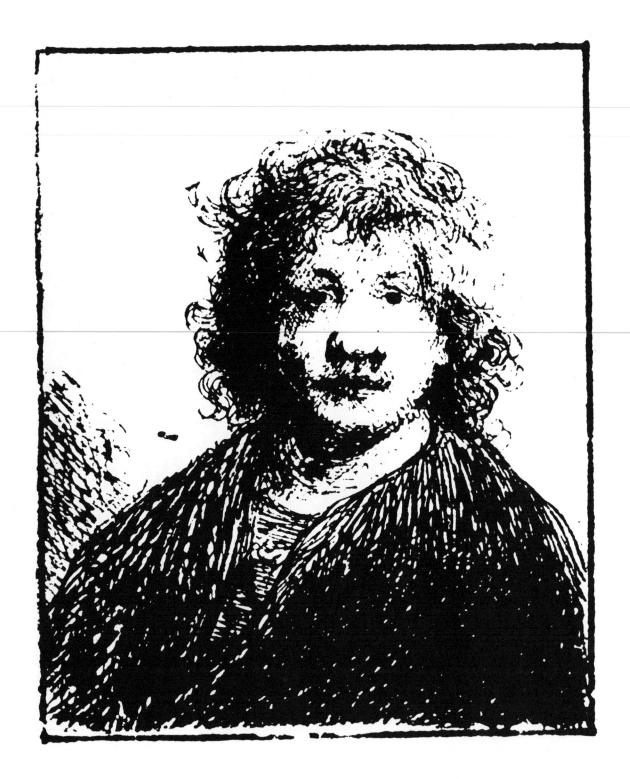

# Rembrandt van Rijn

About 22. Self-portrait.

Born July 15, 1606, in Leiden, The Netherlands.

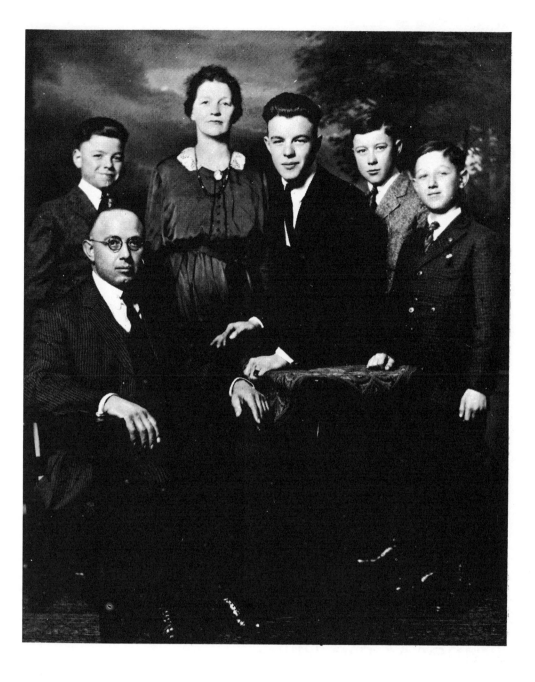

# Walter Reuther

Born September 1, 1907, in Wheeling, West Virginia.

# Roy Reuther

Born August 29, 1909, in Wheeling, West Virginia.

# Victor Reuther

Born January 1, 1912, in Wheeling, West Virginia.

From left to right: Roy (about 11), father Valentine, mother Anna, Ted (the oldest brother), Walter (about 13) and Victor (about 8).

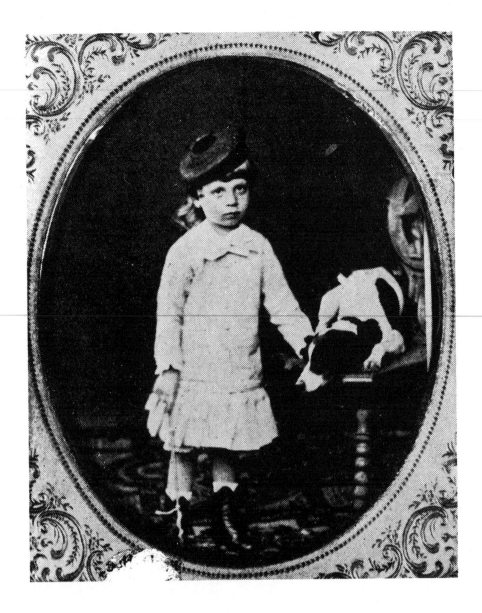

# Rainer Maria Rilke
Age 4.

Born December 4, 1875, in Prague.

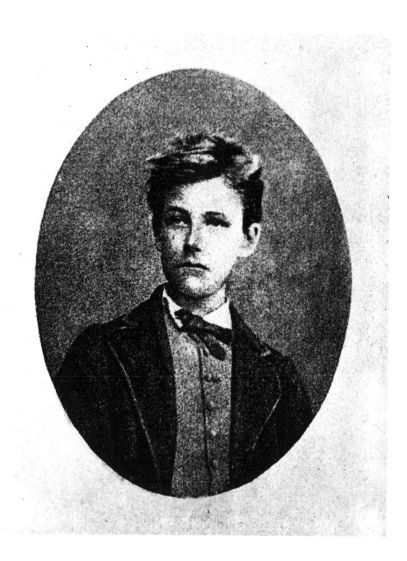

# Arthur Rimbaud
About 17.

Born October 20, 1854, in Charleville, Ardennes, France.

# Oral Roberts

Left, age 11. With his older brother Vaden.

Born January 24, 1918, near Ada, Oklahoma.

# Paul Robeson
About 20. At Rutgers.

Born April 9, 1898,
in Princeton, New Jersey.

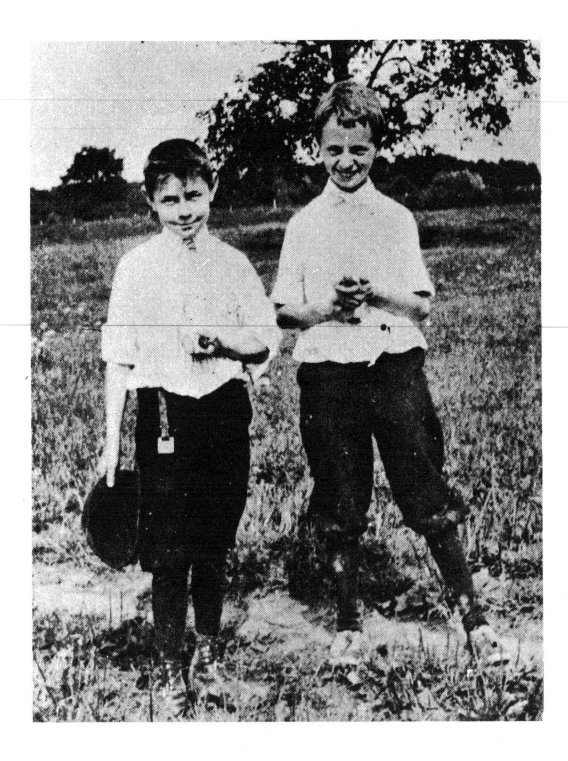

# Norman Rockwell

Right. Holding a frog, with friend.

Born February 3, 1894, in New York City.

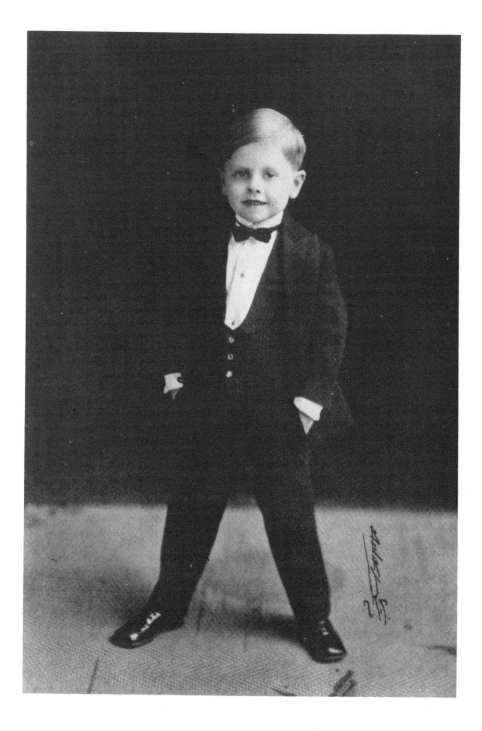

# Mickey Rooney
Age 2.

Born September 20, 1920, in Brooklyn, New York.

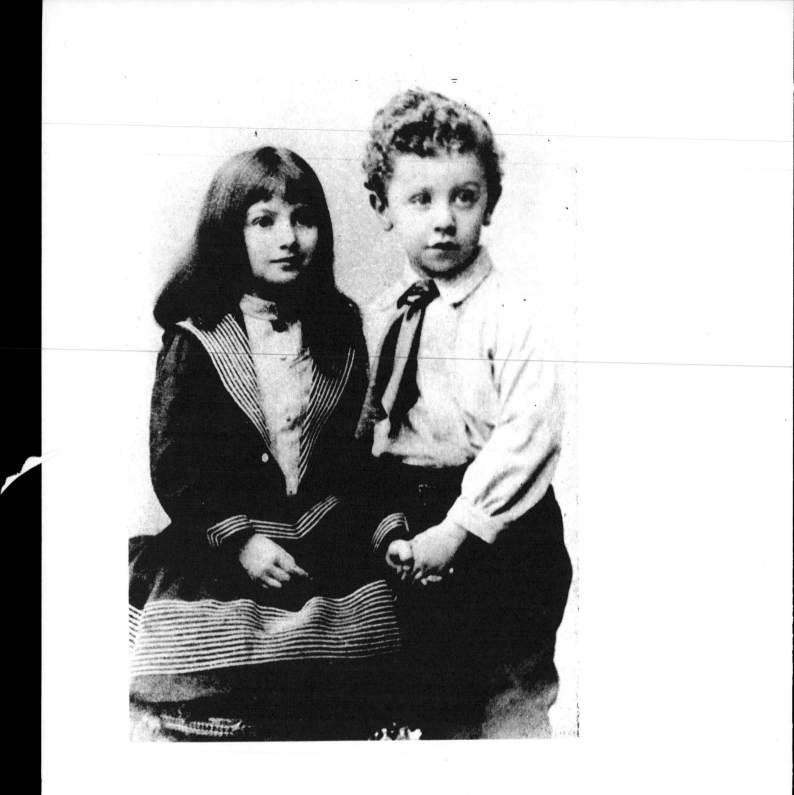

# Artur Rubinstein

Age 4. With his cousin Fania Meyer in Berlin.

Born January 28, 1887, in Lodz, Poland.

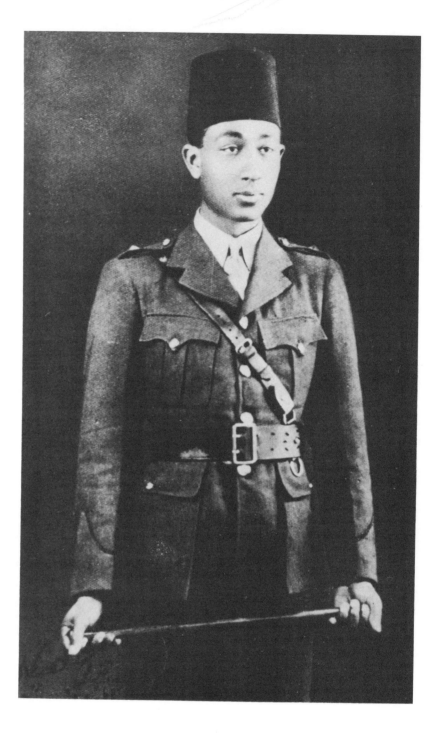

# Anwar el-Sadat
Age 19. Just graduated as second lieutenant
from the Royal Military Academy at Cairo.

Born December 25, 1918, in Mit Abul-Kum, Menufia, Egypt.

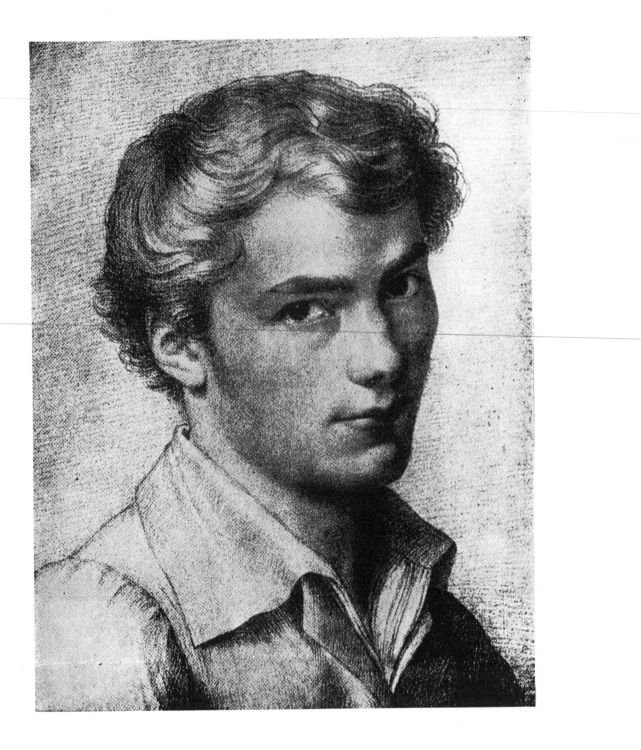

# Franz Schubert
Age 16.

Born January 31, 1797, in Vienna, Austria.

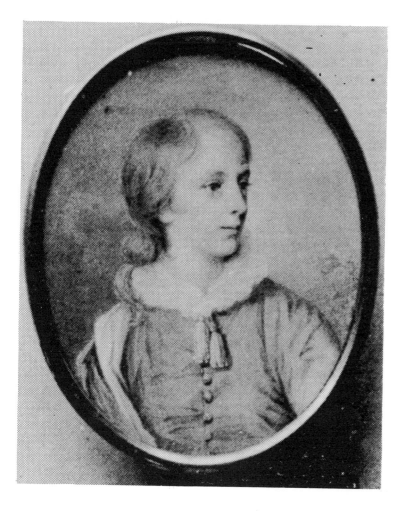

In September [1812], the Home Secretary, whose office presided over a network of informers worthy of a Persian satrap, received a...communication...from John Hopkins, Inspecting Commander of Revenue Cruisers, Western District, enclosing a copy of Shelley's [inflammatory] *Declaration of Rights*, one of his ships "having found the same in a Sealed Wine Bottle, floating near the Entrance of Milford Haven on the 10th Inst."...

The "knowledge" in the bottles apparently traveled far and wide. Milford Haven is in Wales, [50 miles] across the Bristol Channel from Lynmouth Devon [where Shelley was staying].

K. N. Cameron

*On launching some bottles filled with Knowledge into the Bristol Channel.*

Vessels of Heavenly medicine! may the breeze,
Auspicious, waft your dark green forms to shore;
Safe may ye stern the wide surrounding roar
Of the wild whirlwinds and the raging seas;
And oh! if Liberty e'er deigned to stoop
From yonder lowly throne her crownless brow,
Sure she will breathe around your emerald group
The fairest breezes of her west that blow.
Yes! she will waft ye to some freeborn soul
Whose eyebeam, kindling as it meets your freight,
Her heaven-born flame on suffering Earth will light
Until Its radiance gleams from pole to pole
And tyrant-hearts with powerless envy burst
To see their night of ignorance dispersed.

(age 20)

# Percy Bysshe Shelley
Age 12.

Born August 4, 1792,
at Field Place (near Horsham),
Sussex, England.

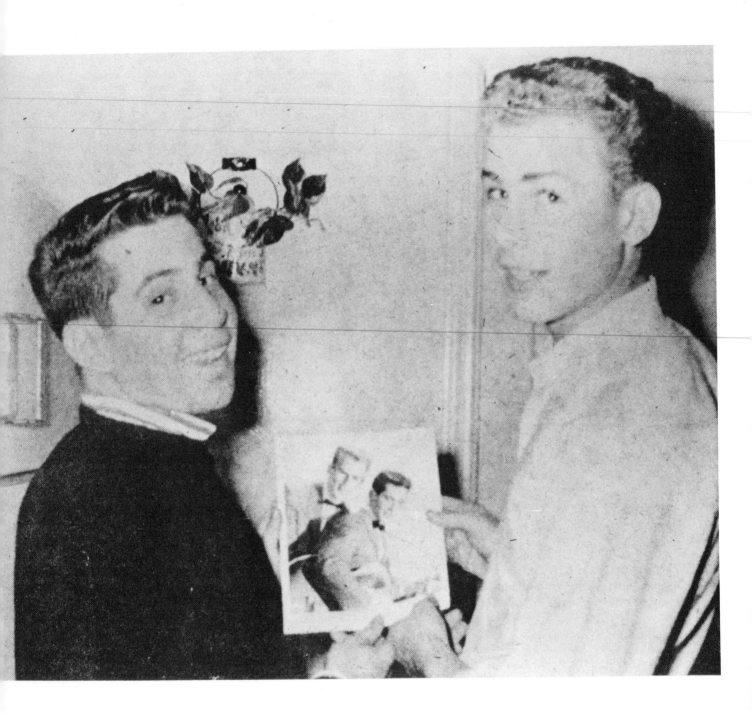

## Paul Simon
Born October 13, 1942, in Newark, New Jersey.

## Art Garfunkel
Born November 5, 1942, in Forest Hills, New York.

Both about 16. Holding publicity photo for their group, Tom & Jerry.

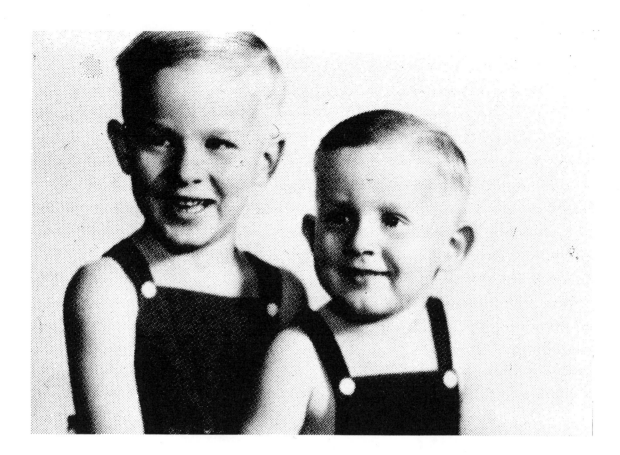

# Dick Smothers

Born November 20, 1939, on Governors Island, New York City.

# Tom Smothers

Born February 2, 1937, on Governors Island, New York City.

Tom left, Dick right.

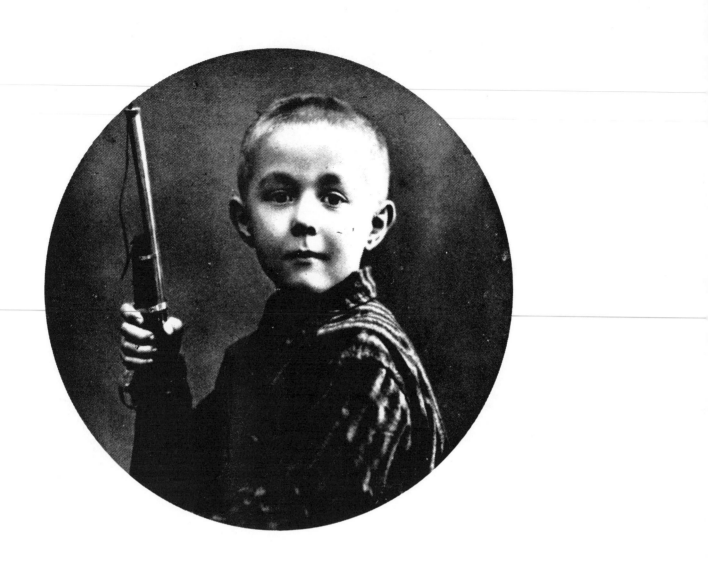

# Aleksandr Solzhenitsyn

Born December 11, 1918, in Kislovodsk, Caucasus, Russia.

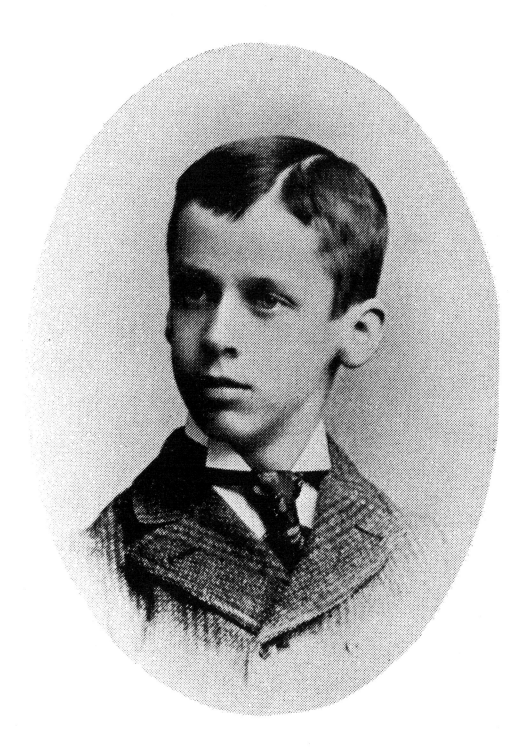

# Norman Thomas

Age 14.

Born November 20, 1884, in Marion, Ohio.

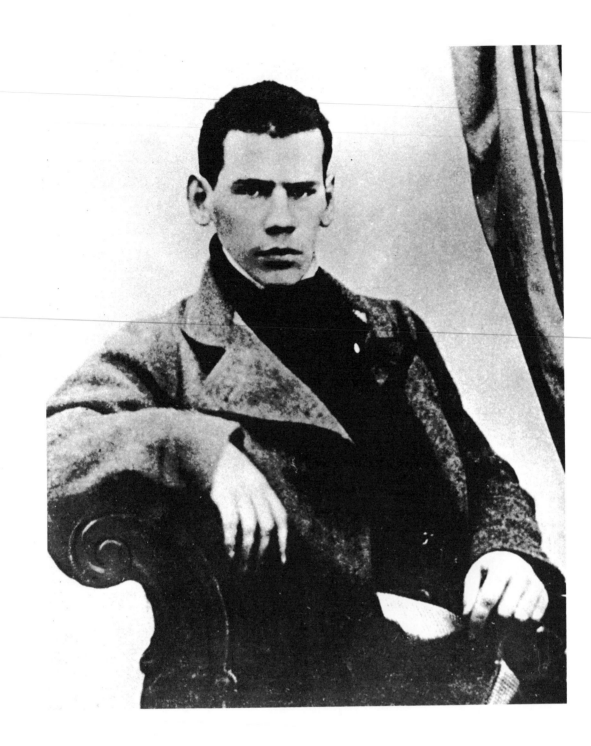

# Leo Tolstoy
Age 20. As a student.

Born August 28, 1828, in Yasnaya Polyana, Tula, Russia.

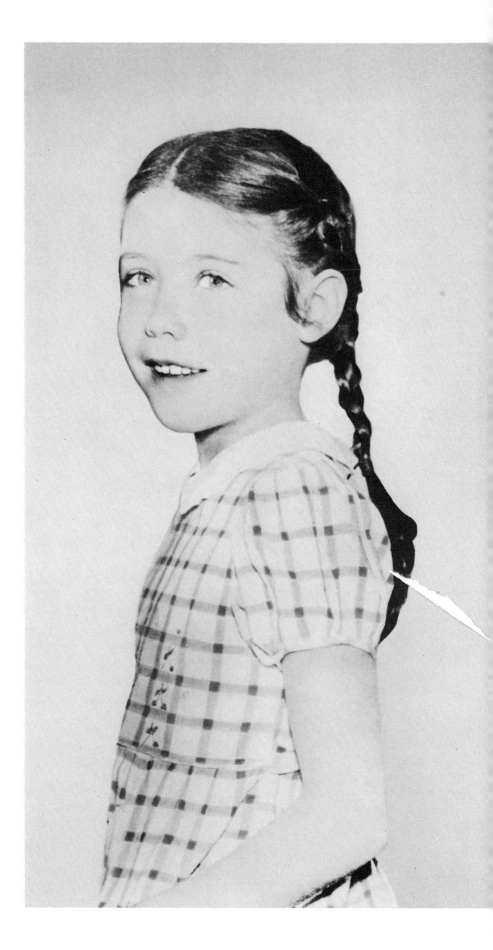

# Lily Tomlin
Age 6.

Born September 1, 1943,
in Detroit, Michigan.

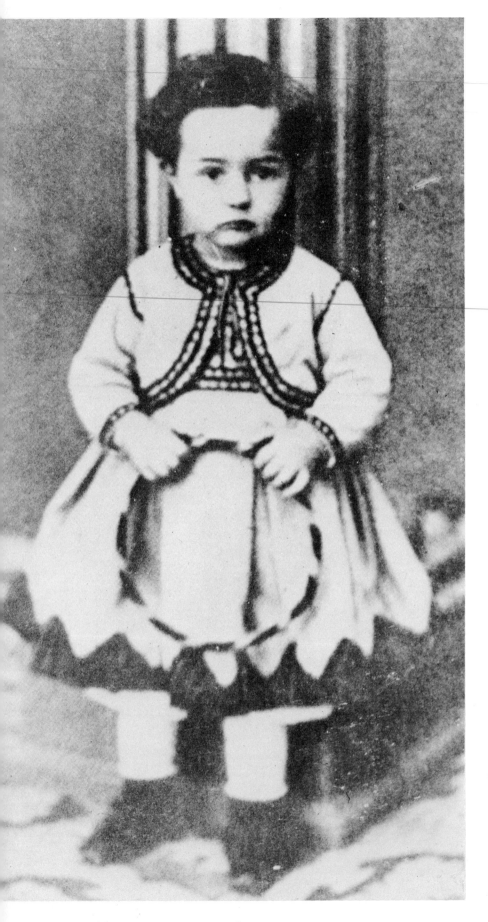

# Henri de Toulouse-Lautrec
Age 3.

Born November 24, 1864,
in Albi, Tarn, France.

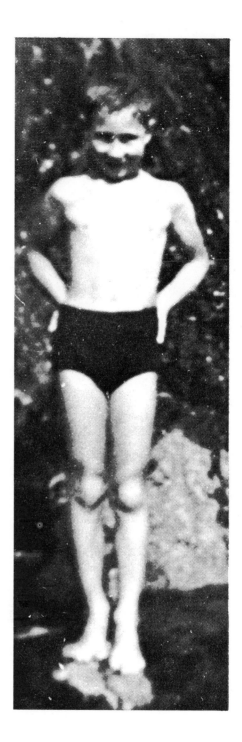

# Peter
# Townshend

Born May 19, 1945,
in Chiswick, London, England.

# John Travolta

Age 1.

Born February 18, 1954, in Englewood, New Jersey.

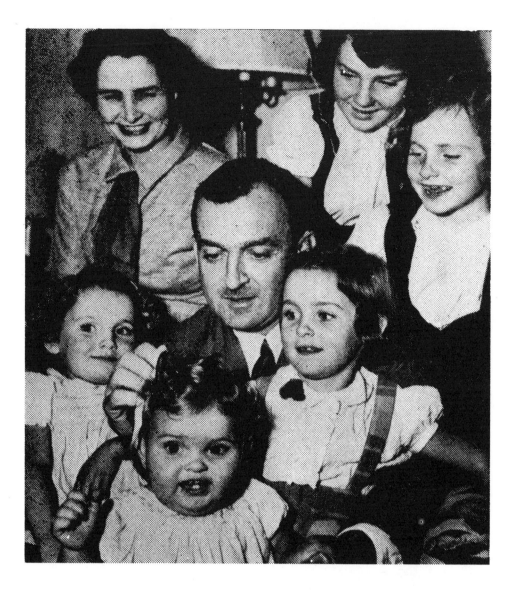

# Margaret Trudeau

Extreme left. Then counterclockwise from the bottom, her sisters
Betsy, Rosalind, Janet, and Heather, with their mother Kathleen and father Jimmy.

Born September 10, 1948, in West Vancouver, British Columbia, Canada.

# Harry Truman
About 16.

Born May 8, 1884, in Lamar, Missouri.

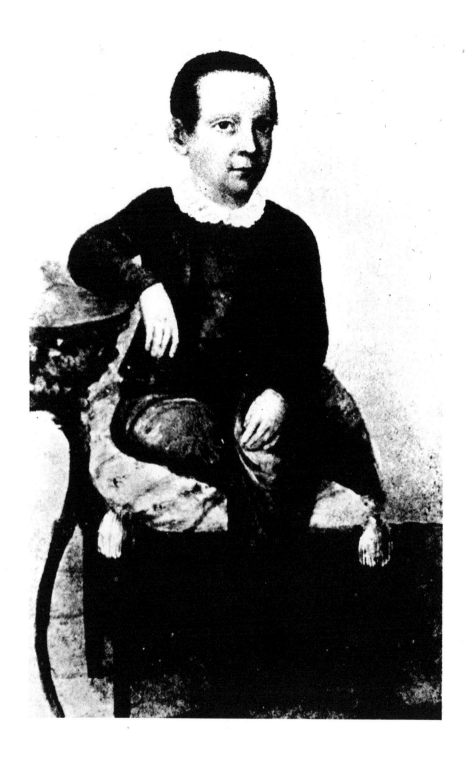

# Ivan Turgenev
About 6.

Born November 9, 1818, in Orel, Russia.

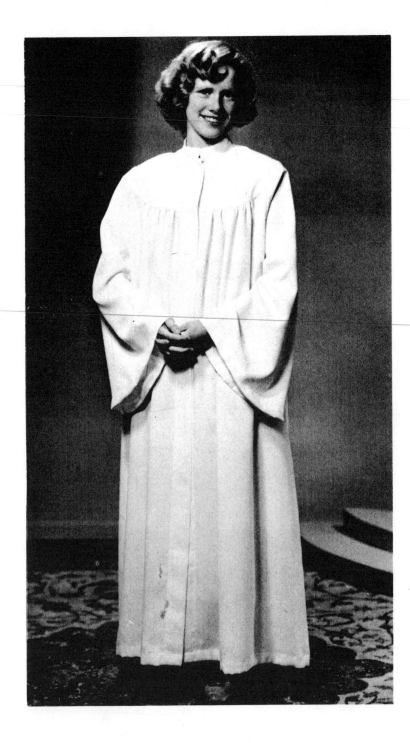

# Liv Ullmann
Age 13. In confirmation robes.

Born December 16, 1939, in Tokyo, Japan.

# Kurt Waldheim

Born December 21, 1918, in Sankt Andrä-Wördern, Austria.

# Barbara Walters

Age 12.

Born September 25, 1931, in Boston, Massachusetts.

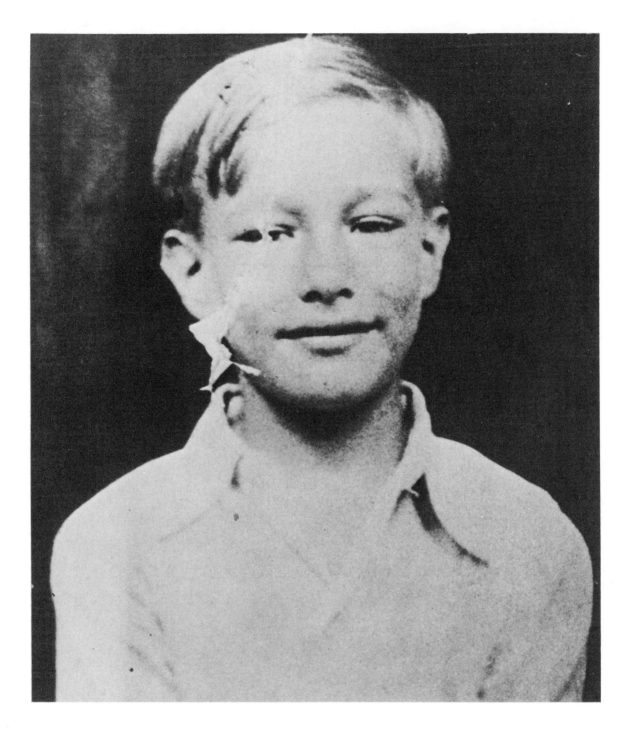

# Andy Warhol
Age 12.

Born August 6, 1928, in Pittsburgh, Pennsylvania.

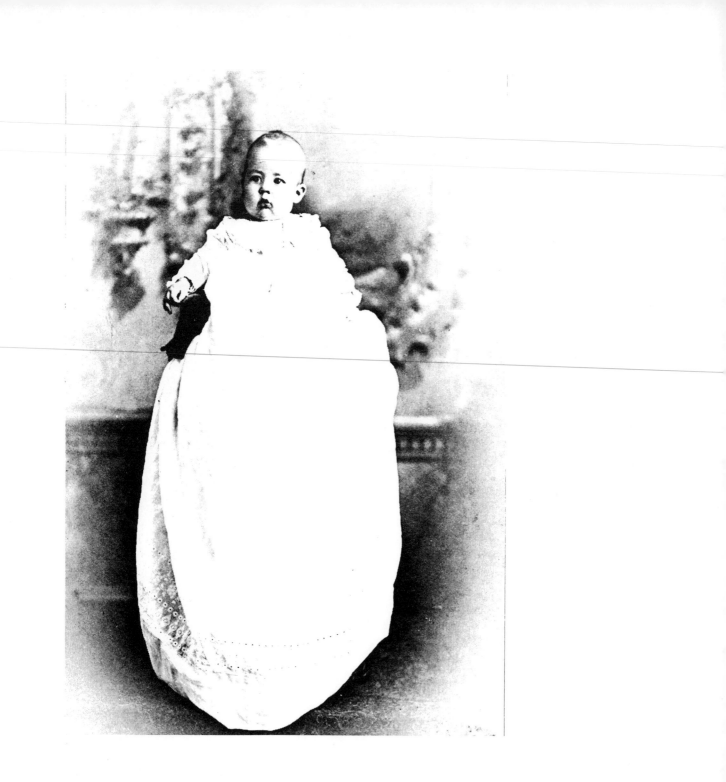

# Earl Warren
Age 3 months.

Born March 19, 1891, in Los Angeles, California.

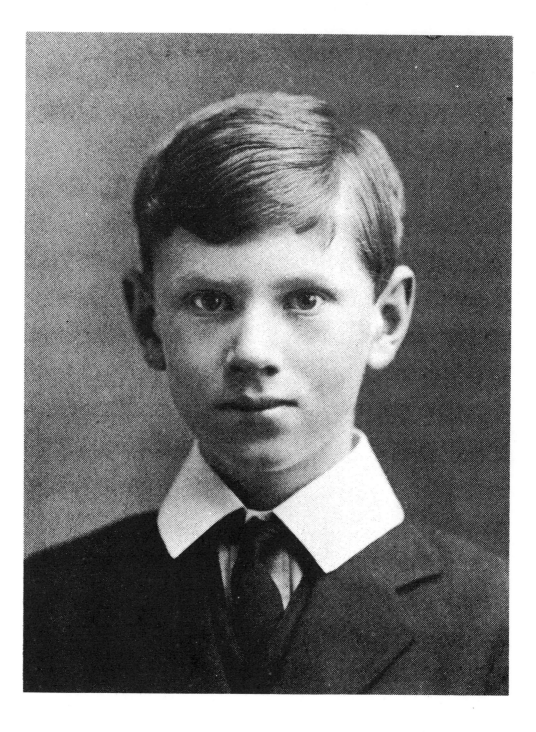

# Evelyn Waugh
Age 10.

Born October 28, 1903, in Hampstead, London, England.

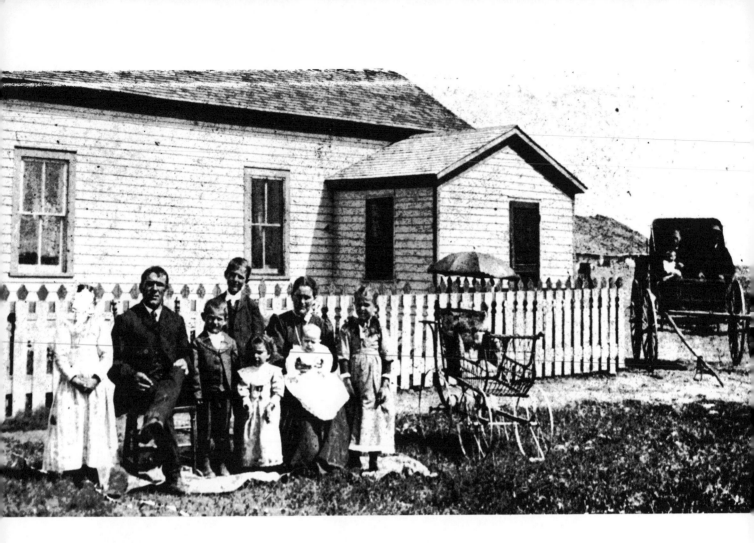

# Lawrence Welk

On mother's lap, with his father and brothers and sisters.

Born March 11, 1903, in Strasburg, North Dakota.

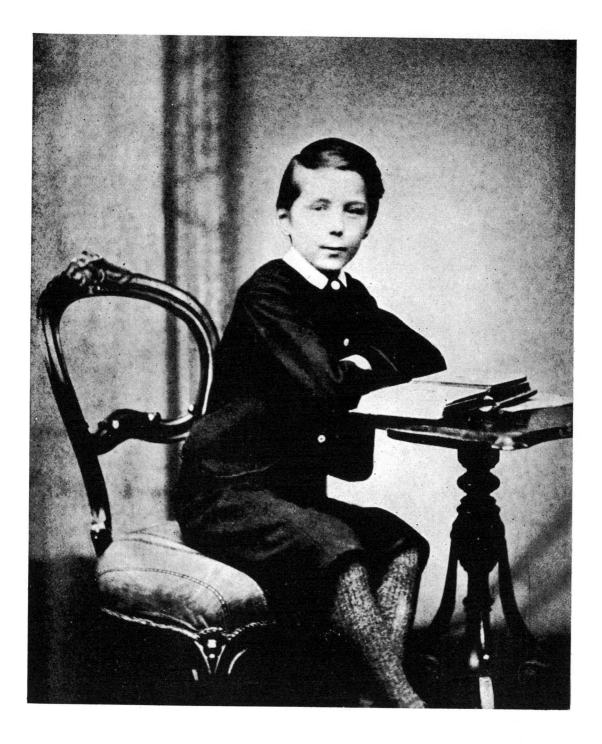

# H. G. Wells
About 10.

Born September 21, 1866, in Bromley, Kent, England.

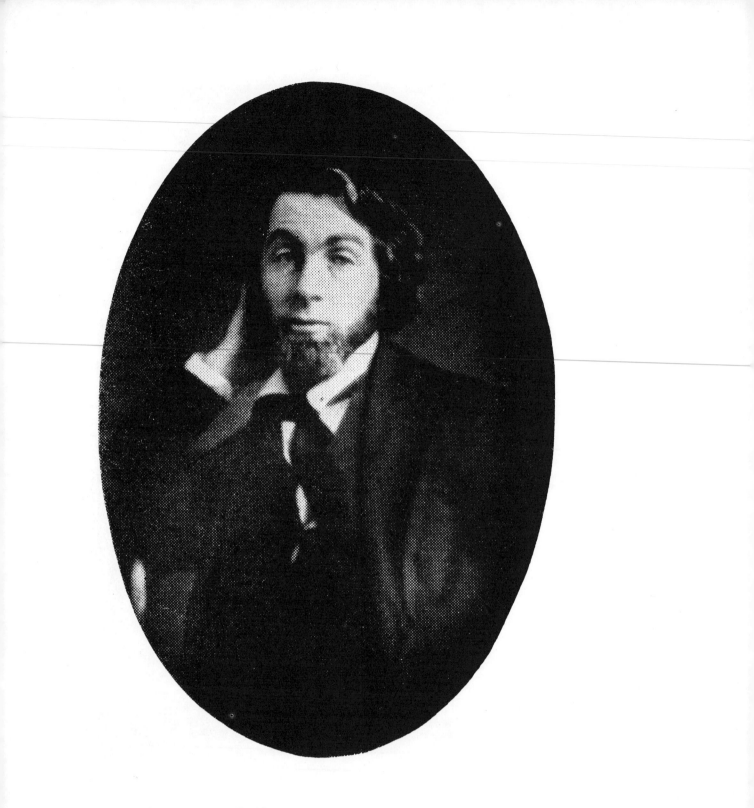

# Walt Whitman

Born May 3, 1819, in West Hills (near Huntington), Long Island, New York.

# Henry Winkler

At 8th birthday party.

Born October 30, 1945, in New York City.

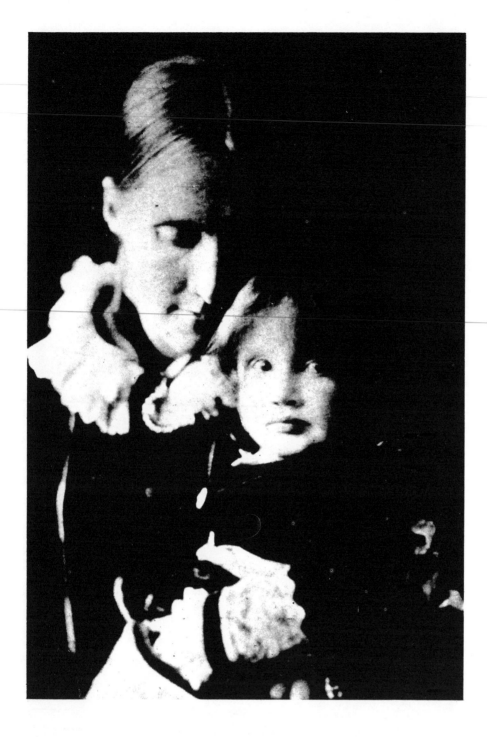

# Virginia Woolf
Age 2. With her mother Julia.

Born January 25, 1882, in London, England.

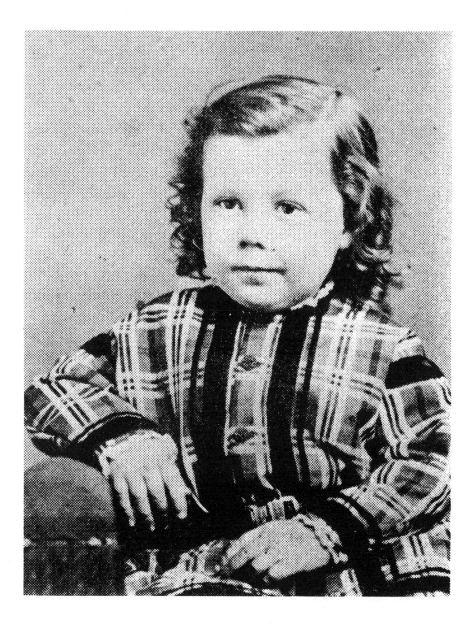

# Frank Lloyd Wright
Age 3.

Born June 8, 1869, in Richland Center, Wisconsin.

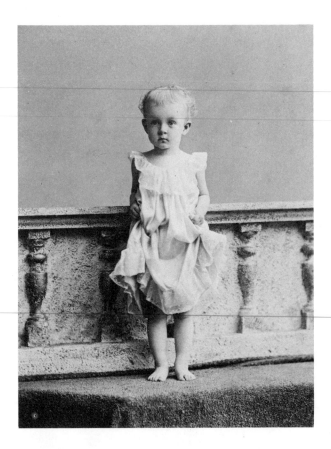

No one famous

## SPECIAL THANKS AND CREDITS

Australian Broadcasting Commission, Richard Avedon, Rob Baker, Bodleian Library, Wallace D. Bonner, Frank Brady, British Information Services in New York City, Brooklyn Public Library, Michael Brown, Cambridge University Library, Hollyer Cameron, Etienne Carjat, Johnny Carson, Jim Charlton, City Museum in Edinburgh, Leonard Cohen, Gerry Davis, Mike Douglas, Down House Archive, Jim Drougas, Edison Laboratory National Monument, Fabulous Music, K.A. Fisher, Flash Books, Ruth Flaxman, Florida State University Library, Myra Friedman, E. Hardebusch, Edith Kupferberg Hoffman, Institute of Marxism-Leninism in Moscow, Israeli Embassy in Washington, D.C., Janssen, Lannes Kenfield, Anton Johann Kern, Ron Kolm, Leopold Kupelwieser, Jennie Kupferberg, W. Latour, Jules Laure, Rosina Liszewska, Jeanette Mall, Marshall McLuhan, Metropolitan Toronto Public Libraries, Alex Miller, Diana Miller, Minnesota Historical Society, Jim Moloshok, Duc de Monpessier, Morgan Library, Rose Namath, Joseph Neesen, New Morning Bookstore, New York Public Library, New York University Libraries, Antoine Pesne, Harry Pincus, University of Pittsburgh Libraries, Public Archives of Canada, Victor Reuther, Oral Roberts, Russian State Museum in Leningrad, Victor Schnittke, J.P. Scholter-van Houten, Ray Siller, Larry Sloman, Doug Smith, Staatsbibliothek in Berlin, Ian Summers, *Swing*, Tamiment Library, University of Toronto Libraries, Lily Tomlin, Marc Tralbout, Turgenev Museum, Kurt Waldheim, James C. Walsh, M.A. Wesner, W. White, Drue Wilson, University of Wisconsin Libraries, Wisconsin State Historical Society, Herb Wise, *Die Zeit*.